Igorot Shields of Moroland Museum

field guide
Fifth Edition
Volume #01

Written by

Author/Publisher	Graphic Artist	Photographer	Legal Council
Bruce Jenkins	**Jess Holloway**	**Bruce Jenkins/ Ben VerVer**	**Frank Gannon**

IGOROT SHIELDS OF MOROLAND MUSEUM by Bruce Jenkins

© 2016 by Moroland Museum. All rights reserved.

No part of this book may be reproduced in any written, electronic, recording, or photocopying form without written permission of the author or Moroland Museum.

Books may be purchased in quantity and/or special sales by contacting Moroland Museum at:

www.morolandmuseum.com
morolandmuseum@gmail.com

Published by: Moroland Museum
Author & Photography by: Bruce Jenkins
Graphic Artist by: Jess Holloway

First Edition

Printed in USA

This book is dedicated to

the people of the Philippines, their weapons and artifacts,

our families and the to all our friends of Moroland.

God bless you all!

IGOROT SHIELDS OF MOROLAND MUSEUM
TABLE OF CONTENTS

DESCRIPTION	LOCATION
Igorot Head Dress	FRONT COVER
Introduction	04
Historical Igorot Background	05
Igorot Shield #01	07
Igorot Shield #02	09
Igorot Shield #03	11
Igorot Shield #04	13
Igorot Shield #05	15
Igorot Shield #06	17
Igorot Shield #07	19
Igorot Shield #08	21
Igorot Shield #09	23
Igorot Shield #10	25
Igorot Shield #11	27
Igorot Shield #12	29
Igorot Shield #13	31
Igorot Shield #14	33
Igorot Shield #15	35
Igorot Shield #16	37
Igorot Shield #17	39
Igorot Shield #18	41
Igorot Shield #19	43
Igorot Shield #20	45
Igorot Shield #21	47
Igorot Shield #22	49
Igorot Shield #23	51
Igorot Shield #24	53
Igorot Shield #25	55
Igorot Shield #26	57
Igorot Shield #27	59
Little Extras of MOROLAND MUSUEM	61
Male Villager Statue	62
Alligator Statue	63
Warrior Statue	64
Headhunter Axes	65
Wooden Jeepney	66
Conclusion	67
Statements	68
About Next Edition	69
Metal Rickshaw	BACK COVER

IGOROT SHIELDS OF MOROLAND MUSEUM
INTRODUCTION

This book was created as a Historical Pictorial Publication for use by collectors and people wanting to have a reference guide for Igorot Shields. These shields range in size from miniature shields just two inches in height to over three feet in height.

Each shield has its own story to tell as to who made it, how it was made and what purpose was it made for. These shields have many uses such as protection from arrows during fighting with enemies, for ceremonies and to be sold\traded as tourist souvenirs.

The front of these shields have many different types of carvings on them from faces, animals, flowers, basic pictorial scenes to no carvings at all. These shields are made out of many types of wood. Some of these shields are stained and others have no stain at all.

A few of these shields have earrings (metal\wood) attached to the ear lobes on the faces carved into the shield. One of these shields has the carved seal of the "University of Baguio City" and is dedicated to a professor from the college.

IGOROT SHIELDS OF MOROLAND MUSEUM
BACKGROUND

Igorot Shields Historical Background:

This book represents a unique part of the Filipino history. The shields in this book were purchased from many different sellers, from many different countries. Although the exact age of these shields are hard to determine, The MOROLAND MUSUEM field collections specialist have meet many of the original people who purchased these shields while they were in the military (veterans) or as tourist giving the MOROLAND MUSEUM an approximate date range as to the age of the shields presented in these books. These shields were purchased by their original owners starting from 1940's, up to the early 1990's.

Igorot "Mountain People"

Igorot or Cordillerans, is a collective name of several ethnic groups in the Philippines who inhabit the mountains of Luzon. These highland peoples inhabit the six provinces of the Cordillera Administrative Region.

This region consists of the following defined areas: Abra, Apayao, Benguet (Baguio City), Kalinga, Ifugao, Mountain Province (Nueva Vizcaya).

The Igorots may be roughly divided into two general subgroups: the larger group lives in the south, central and western areas, and is very adept at rice-terrace farming; the smaller group lives in the east and north.

They may be further subdivided into five ethnolinguistic groups: the Bontoc, Ibaloi, Isnag (or Isneg/Apayao), Kalinga, and the Kankanaey.

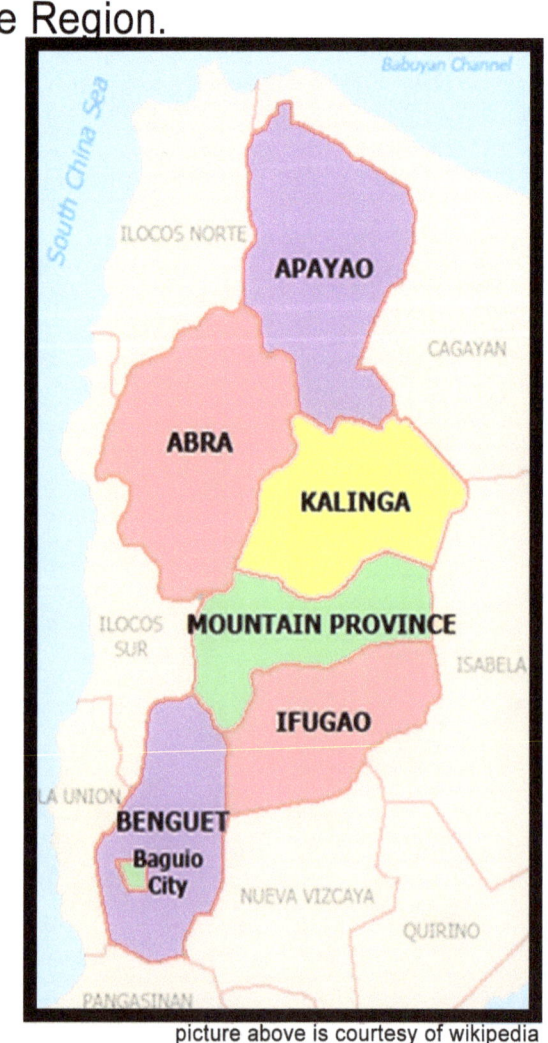

picture above is courtesy of wikipedia

IGOROT SHIELDS OF MOROLAND MUSEUM
BACKGROUND

Volumes:

This book is the first volume in a multi-volume set of books documenting these unique Igorot shields from the Philippines. As the MOROLAND MUSEUMS' collection of Igorot shields continues to grow, the MOROLAND MUSEUM Historical Publications team will continue their dedication to get these books published for all people to enjoy.

Hard to find:

The older Igorot shields are getting hard to find and even harder to find in good condition. The shields crafted prior to the 1940's are the most difficult to find, due to a lot of them being destroyed during the Japanese occupation of the Philippines during WWII and to the environment they were stored in.

Military Personnel's influence on these Igorot Shields:

Although many tourist have brought these shields home from the Philippines, the majority of these shields were brought home by the Service men\ women from the major wars (WWII, Korea, Vietnam) and while on deployment to (near) the area during peaceful times. They were brought home as souvenirs from their foreign country travels to share with their families and friends.

Craftsmanship and Quality:

Most of these shields show a very high level of craftsmanship and quality. When you inspect the different types of Igorot shields, the detail put into each one is obvious as they are like masterpieces on which the craftsman shows off their talents.

IGOROT SHIELDS OF MOROLAND MUSEUM

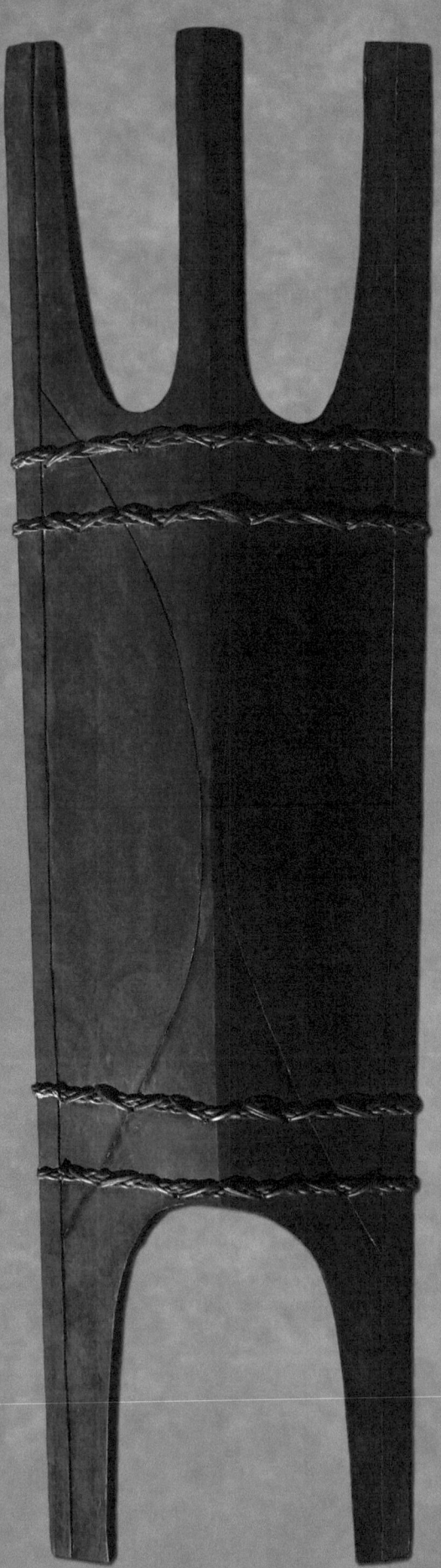

Igorot Shield: #01 Philippines Igorot Shields

IGOROT SHIELDS OF MOROLAND MUSEUM

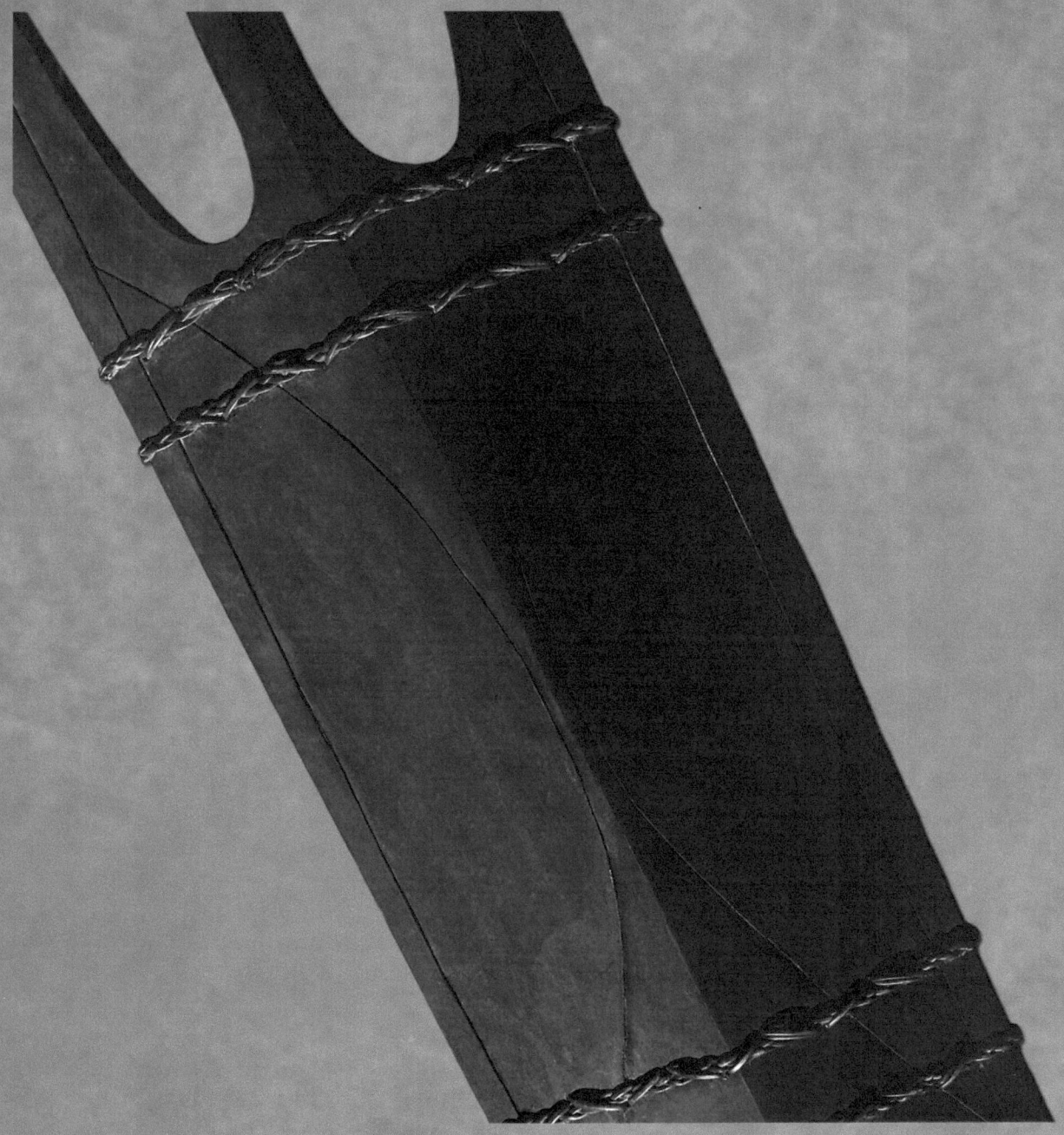

Igorot Shield: #01 Philippines Igorot Shields

Description:
 Igorot Ifugao Bontoc warrior fighting shield, dark native wood, handmade with two rattan wrappings on top and bottom.

Location Found:	Luzon, Philippines	**Length:**	38 inches
Location Purchased:	EBay	**Width:**	11 inches
Approximate Age:	1950's	**Condition:**	Above Average

IGOROT SHIELDS OF MOROLAND MUSEUM

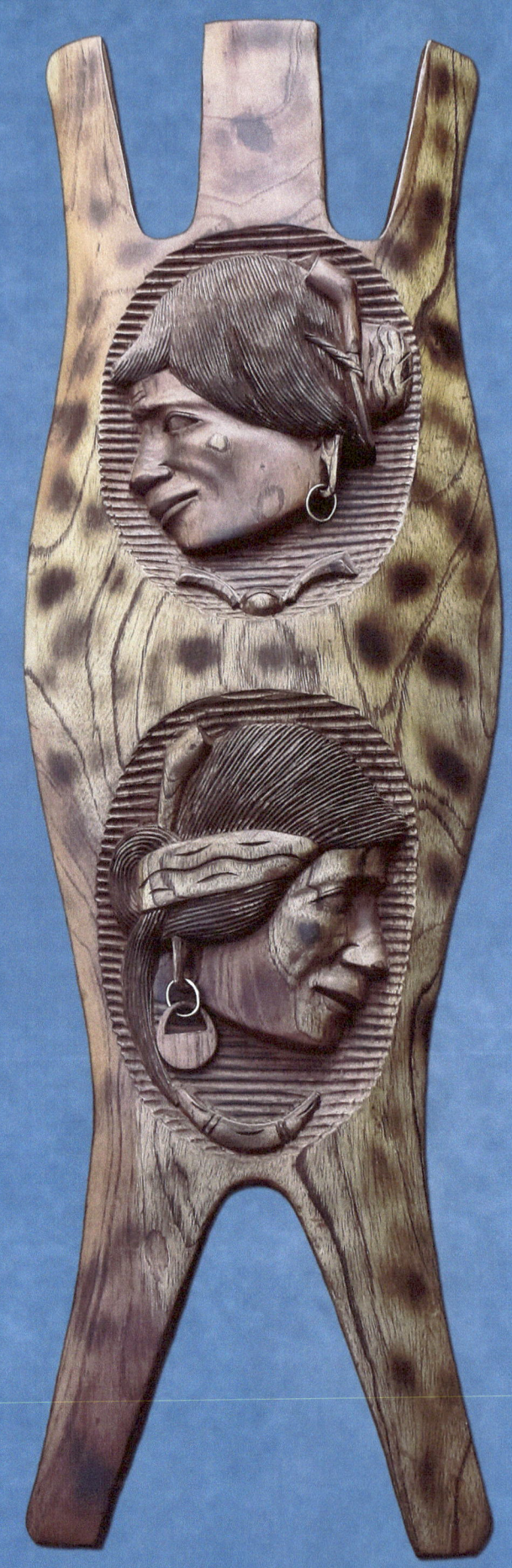

Igorot Shield: #02 Philippines Igorot Shields

IGOROT SHIELDS OF MOROLAND MUSEUM

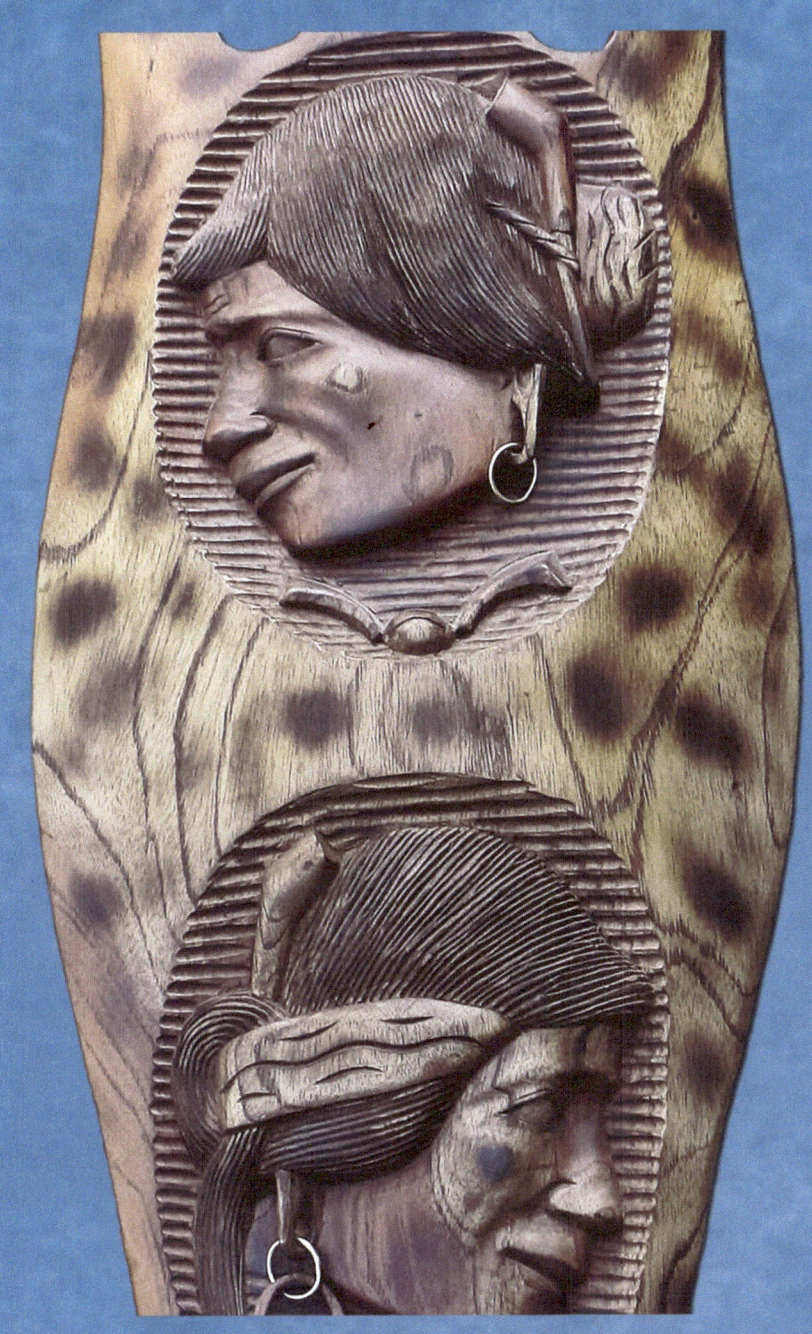

Igorot Shield: #02 Philippines Igorot Shields

Description:
 Vintage Igorot Ifugao Bontoc warrior fighting shield, leopard pattern on native wood, hand carved with two warrior faces on top and bottom. One metal earring on one warrior's ear lobe and one wooden earring on the second warrior's ear lobe.

Location Found:	Manila, Philippines	**Length:**	41 inches
Location Purchased:	EBay	**Width:**	12 inches
Approximate Age:	1970's	**Condition:**	Museum Quality

IGOROT SHIELDS OF MOROLAND MUSEUM

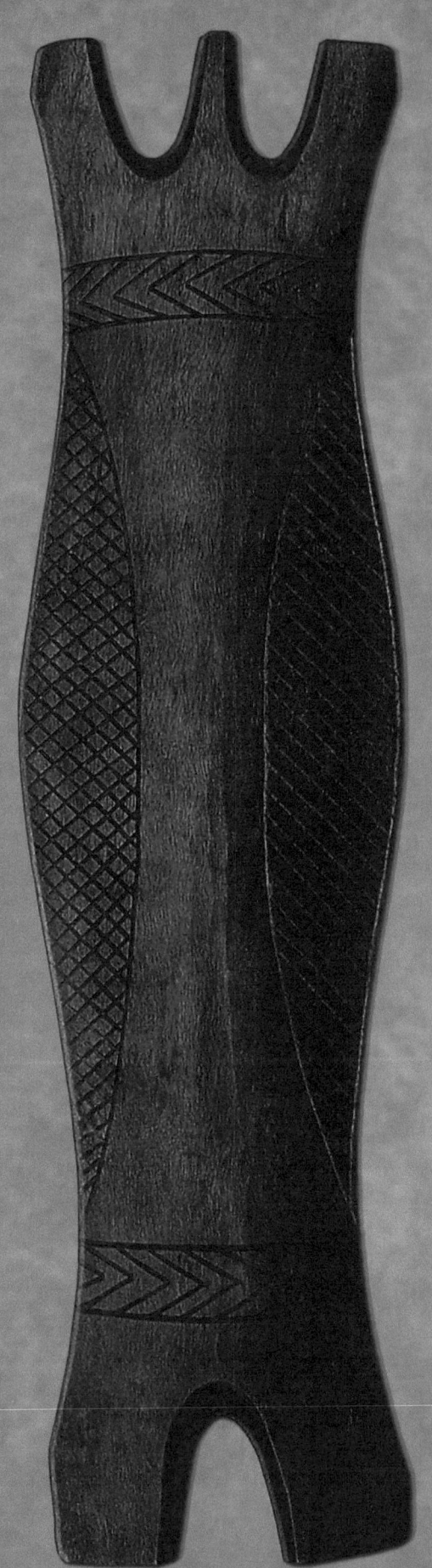

12 **Igorot Shield: #03 Philippines Igorot Shields**

IGOROT SHIELDS OF MOROLAND MUSEUM

Igorot Shield: #03 Philippines Igorot Shields

Description:

 This is a vintage hand carved Philippines Ifugao, Igorot Bontoc Ceremonial Wooden Shield. This particular shield is referred to as a kalasag. It was created as a tourist piece for decoration or possibly used in a ceremony of some type.

Location Found:	Manila, Philippines	**Length:**	24 inches
Location Purchased:	EBay	**Width:**	7 inches
Approximate Age:	1970's	**Condition:**	Above Average

IGOROT SHIELDS OF MOROLAND MUSEUM

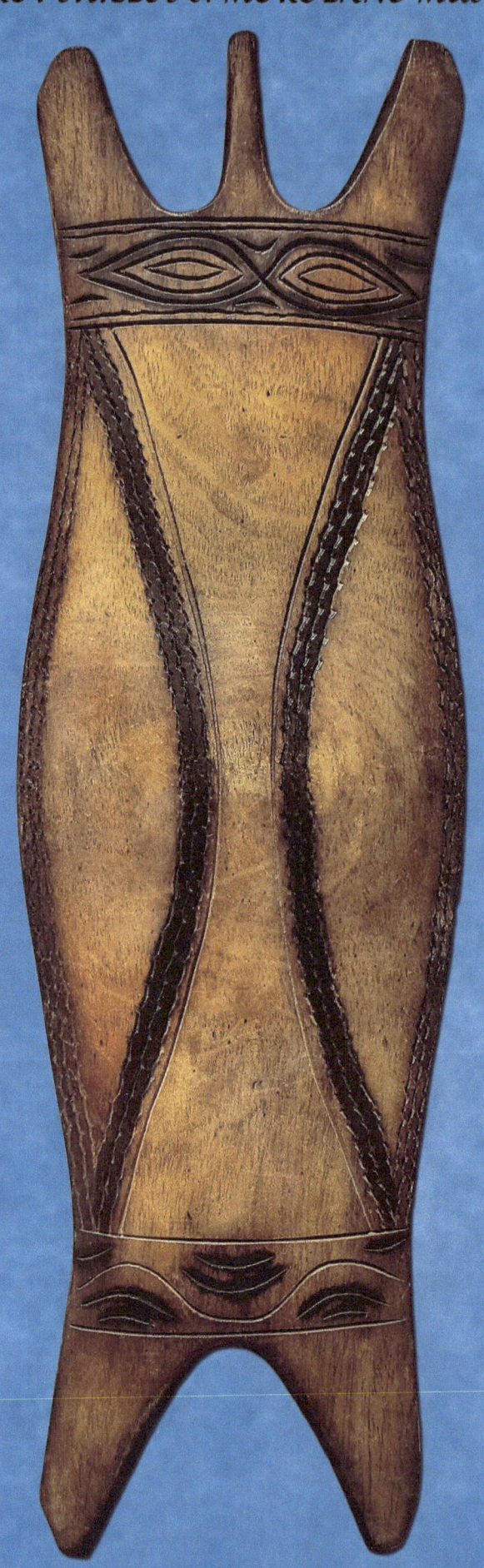

14 **Igorot Shield:** #04 Philippines Igorot Shields

IGOROT SHIELDS OF MOROLAND MUSEUM

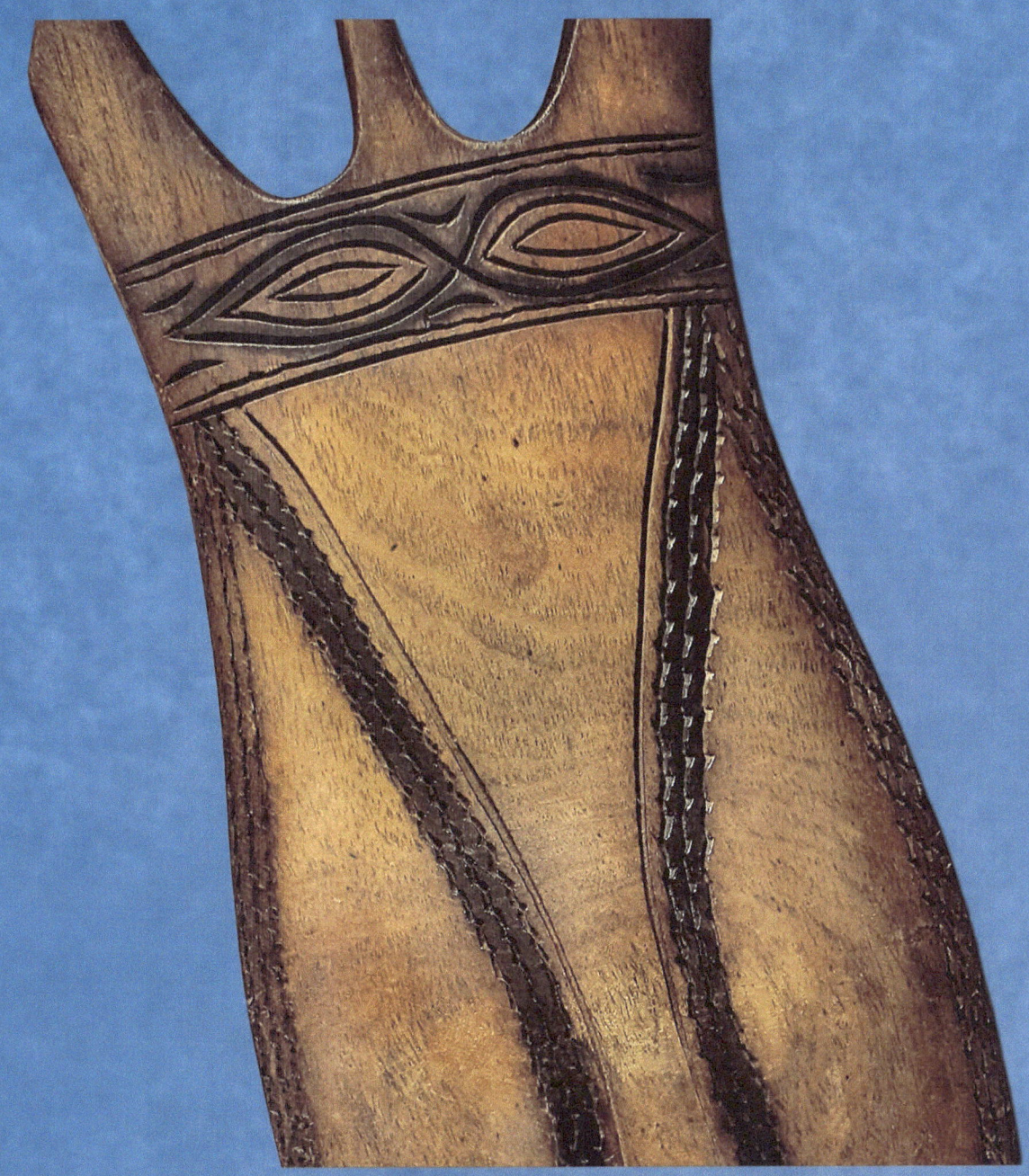

Igorot Shield: #04 Philippines Igorot Shields

Description:
 This is a vintage hand carved Philippines Ifugao, Igorot Bontoc Ceremonial Wooden Shield. This particular shield is referred to as a kalasag. It was created as a tourist piece for decoration or possibly used in a ceremony of some type.

Location Found:	Manila, Philippines	**Length:**	24 inches
Location Purchased:	EBay	**Width:**	7 inches
Approximate Age:	1970's	**Condition:**	Above Average

IGOROT SHIELDS OF MOROLAND MUSEUM

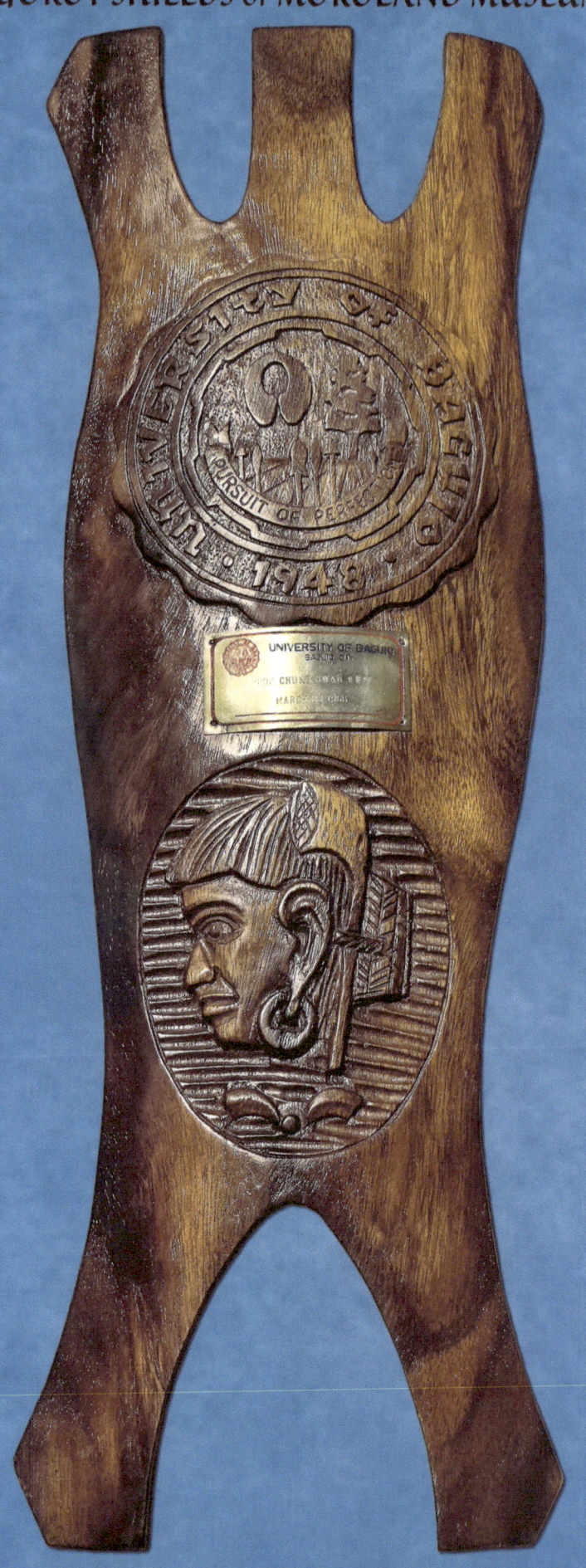

Igorot Shield: #05 Philippines Igorot Shields

IGOROT SHIELDS OF MOROLAND MUSEUM

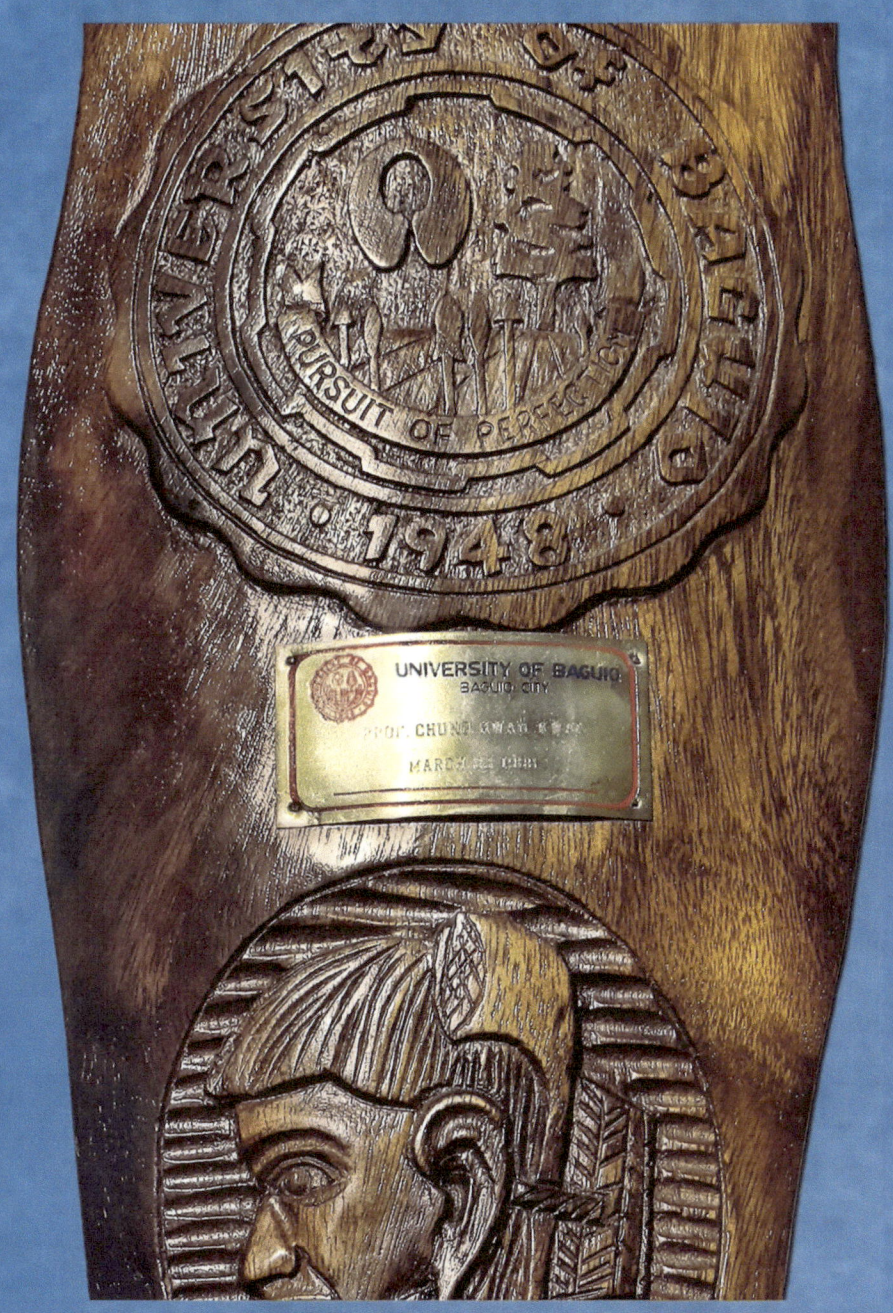

Igorot Shield: #05 Philippines Igorot Shields

Description:
A wood shield from 1986 in great condition. It weighs 3 lb, 8 oz. Hand carved from dark solid monkey-pod wood. Made like the Native Bontoc Igorot Headhunter shields and has a carving of a Native profile on the lower section. The top section has University of Baguio, Pursuit of Perfection, a pine tree, spears, arrows, and 1948. There is a small gold plate that reads "University of Baguio, Baguio City, Prof. Chung Hwan Kwak, March 23, 1986".

Location Found:	Baguio City, Philippines	**Length:**	31 inches
Location Purchased:	EBay	**Width:**	9 inches
Approximate Age:	1986	**Condition:**	Above Average

IGOROT SHIELDS of MOROLAND MUSEUM

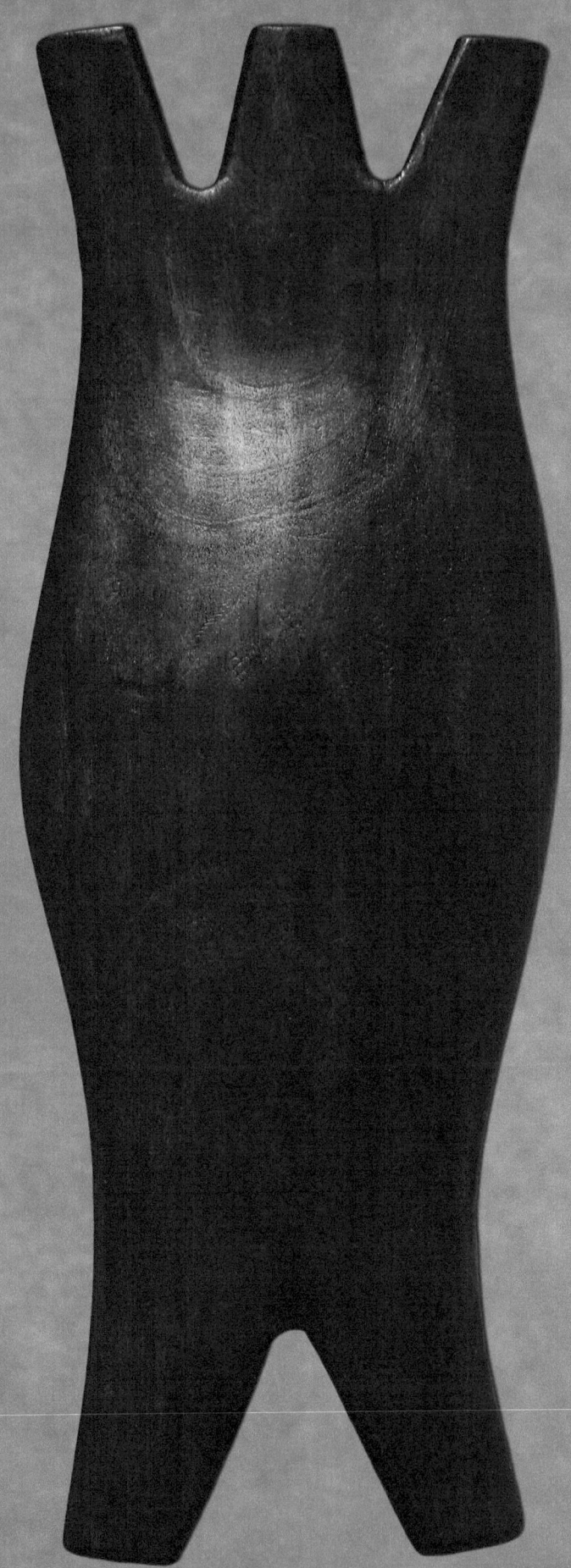

Igorot Shield: #06 Philippines Igorot Shields

IGOROT SHIELDS OF MOROLAND MUSEUM

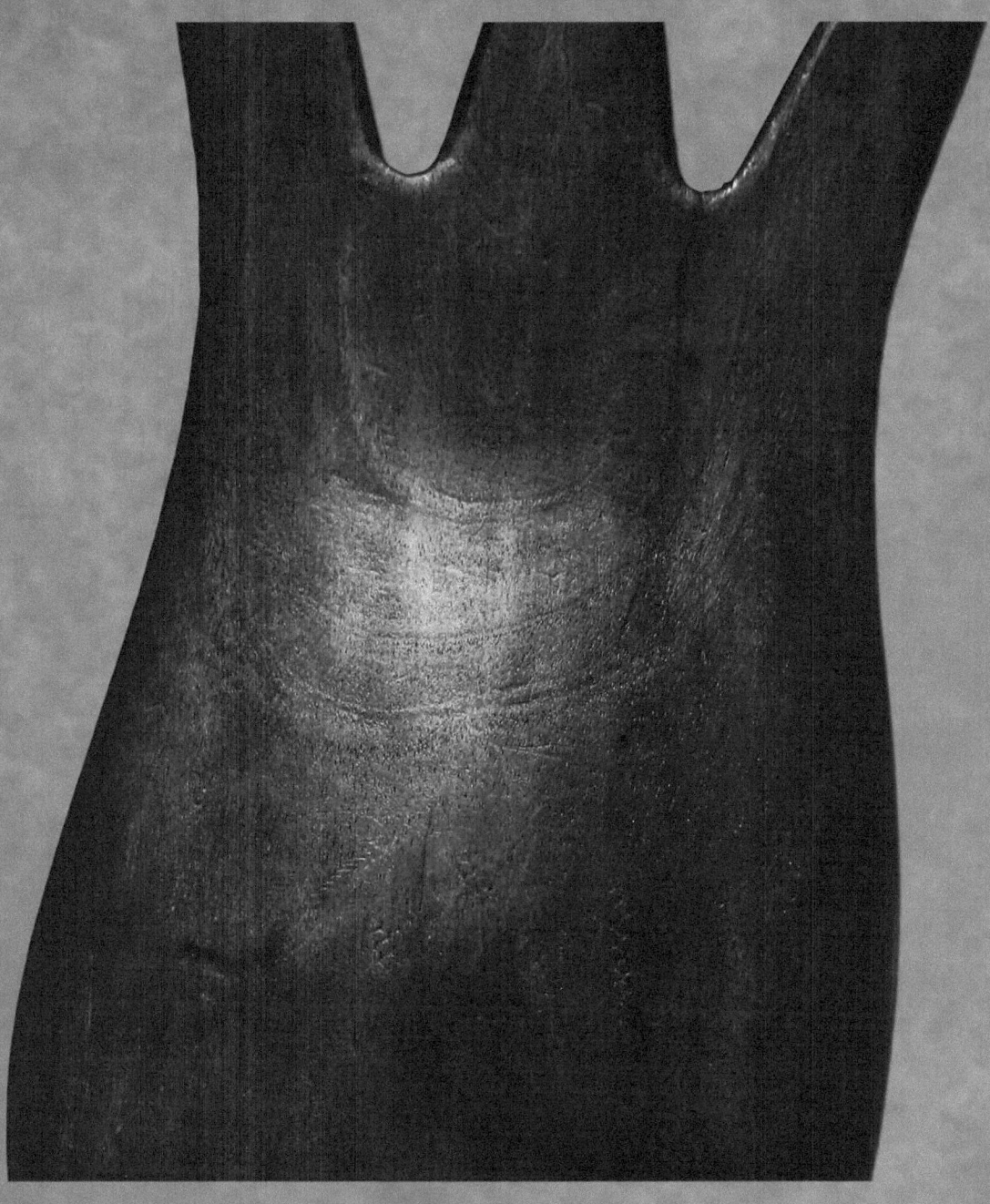

Igorot Shield: #06 Philippines Igorot Shields

Description:
 This is a vintage hand carved Philippines Ifugao, Igorot Bontoc decorative warrior shield. This particular shield is referred to as a kalasag. It was created as a tourist piece for decoration or possibly used in a ceremony of some type. It is made out of a single piece of wood.

Location Found:	Luzon, Philippines	**Length:**	24 inches
Location Purchased:	EBay	**Width:**	8.5 inches
Approximate Age:	1980's	**Condition:**	Museum Quality

IGOROT SHIELDS OF MOROLAND MUSEUM

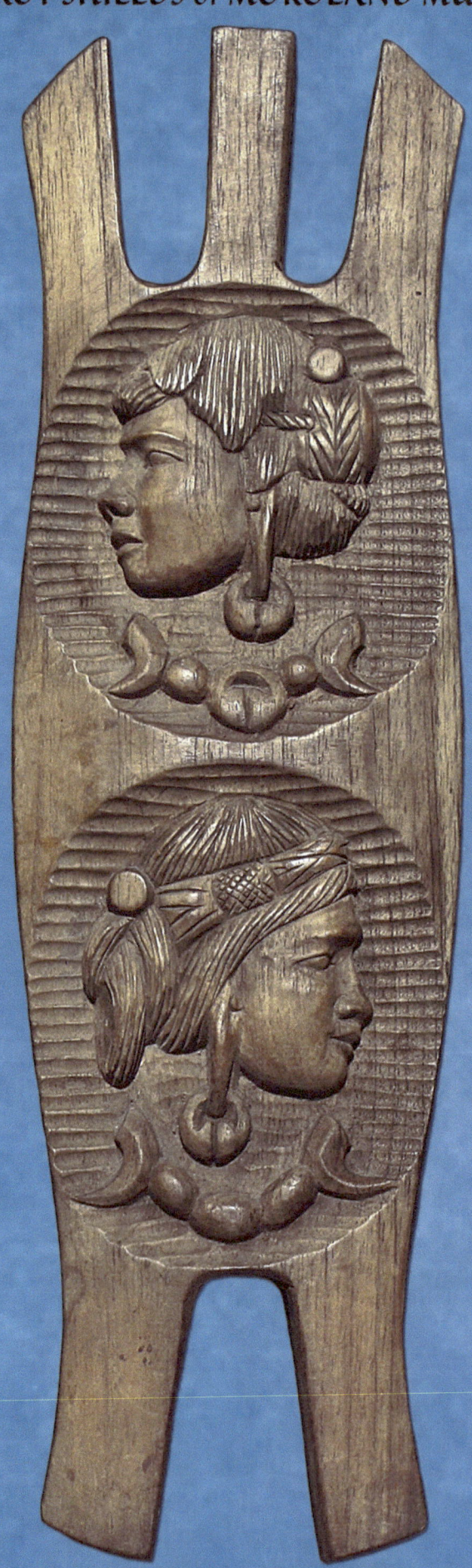

20 Igorot Shield: #07 Philippines Igorot Shields

IGOROT SHIELDS OF MOROLAND MUSEUM

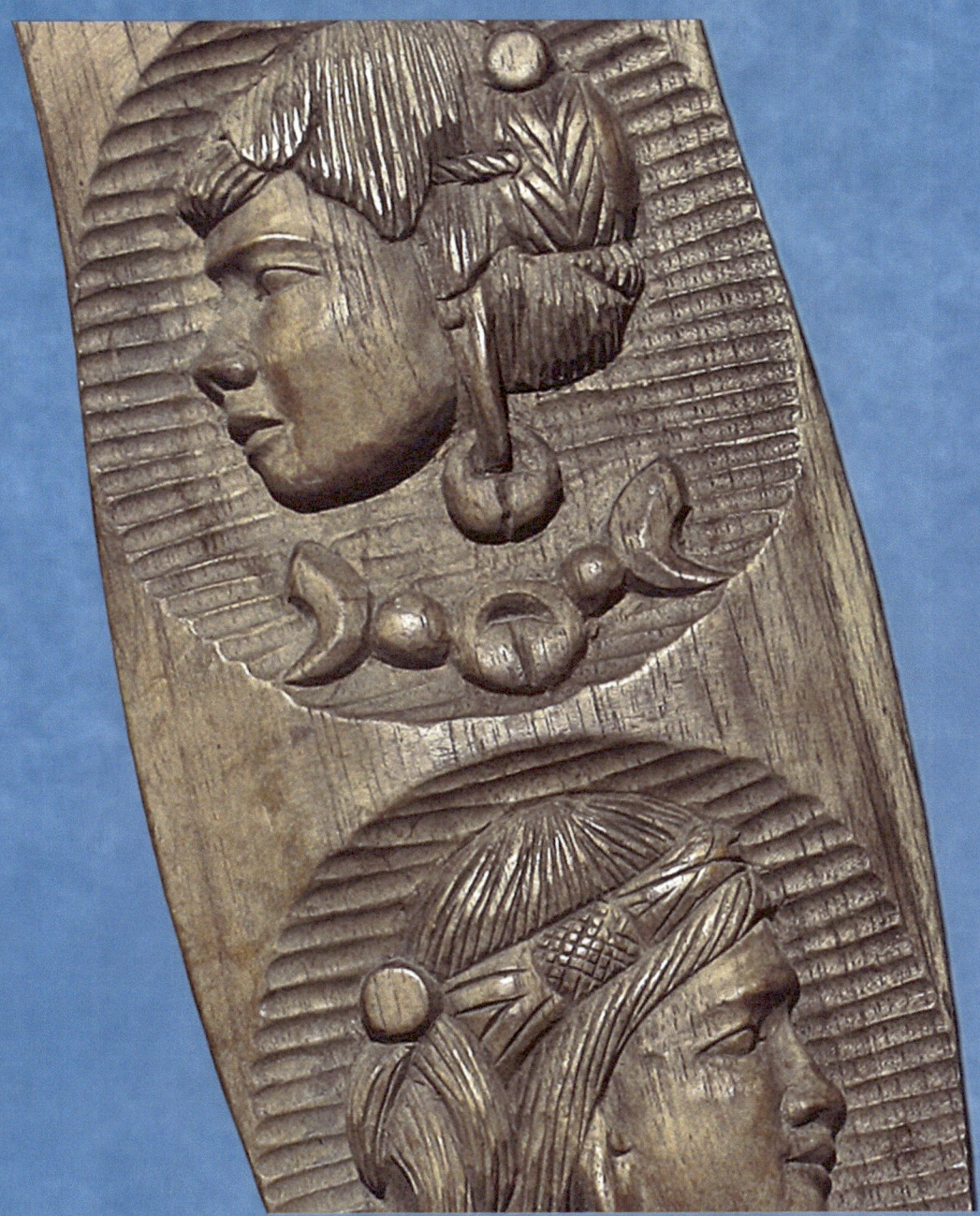

Igorot Shield: #07 Philippines Igorot Shields

Description:
 This is a vintage hand carved Philippines Ifugao, Igorot Bontoc Ceremonial Wooden Shield. This particular shield is referred to as a kalasag. It was created as a tourist piece for decoration or possibly used in a ceremony of some type. It has two Igorot warrior heads carved on the front with tobacco pipes fashioned in the hair.

Location Found:	Manila, Philippines	**Length:**	20.5 inches
Location Purchased:	EBay	**Width:**	7.5 inches
Approximate Age:	1960's	**Condition:**	Museum Quality

IGOROT SHIELDS OF MOROLAND MUSEUM

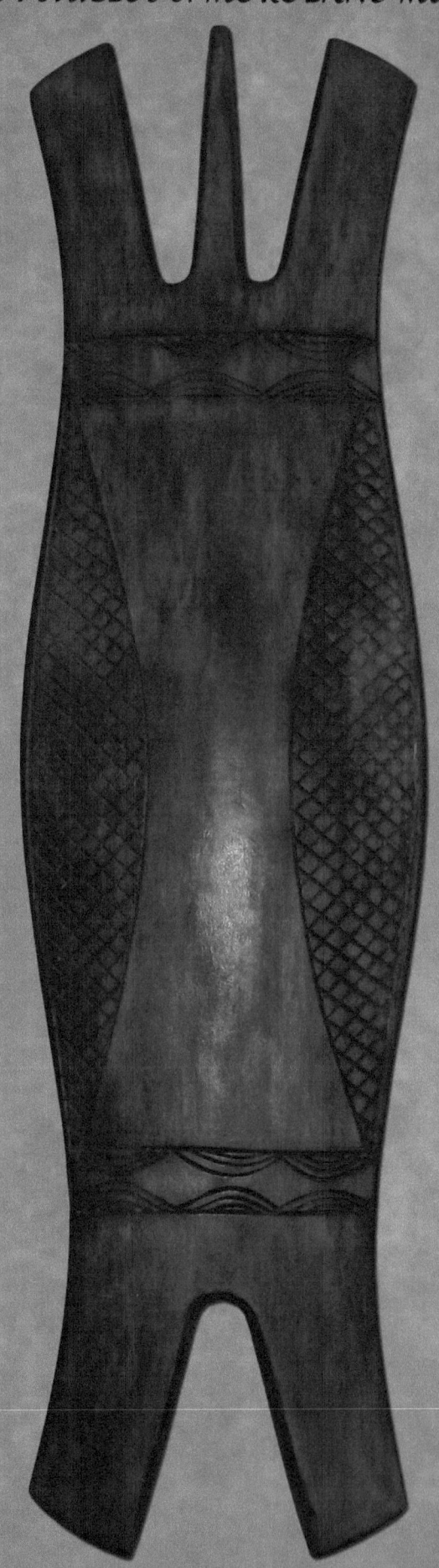

Igorot Shield: #08 Philippines Igorot Shields

IGOROT SHIELDS OF MOROLAND MUSEUM

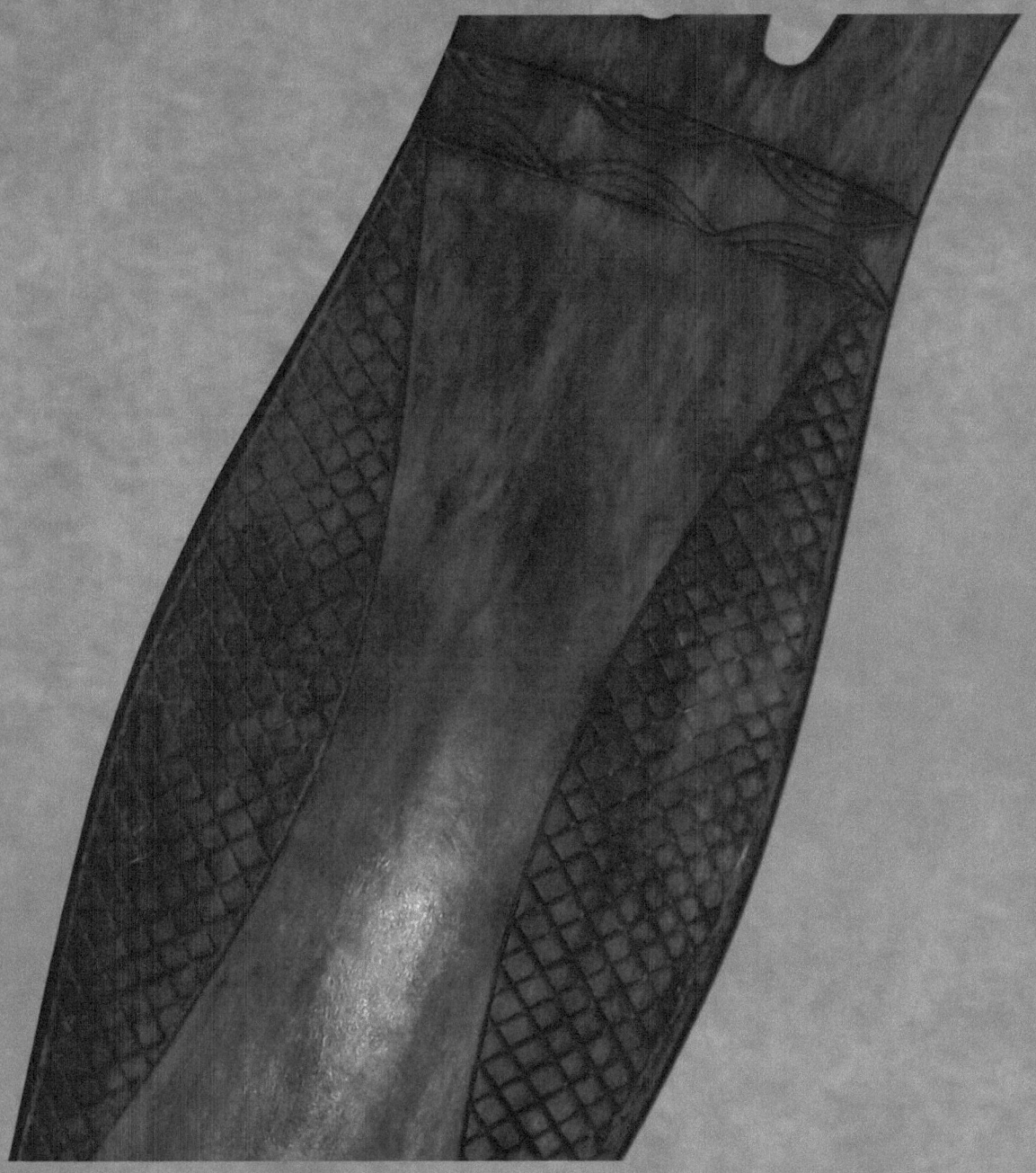

Igorot Shield: #08 Philippines Igorot Shields

Description:
 This is a vintage hand carved Philippines Ifugao, Igorot Bontoc Ceremonial Wooden Shield. This particular shield is referred to as a kalasag. It was created as a tourist piece for decoration or possibly used in a ceremony of some type.

Location Found:	Manila, Philippines	**Length:**	24 inches
Location Purchased:	EBay	**Width:**	7 inches
Approximate Age:	1970's	**Condition:**	Above Average

IGOROT SHIELDS OF MOROLAND MUSEUM

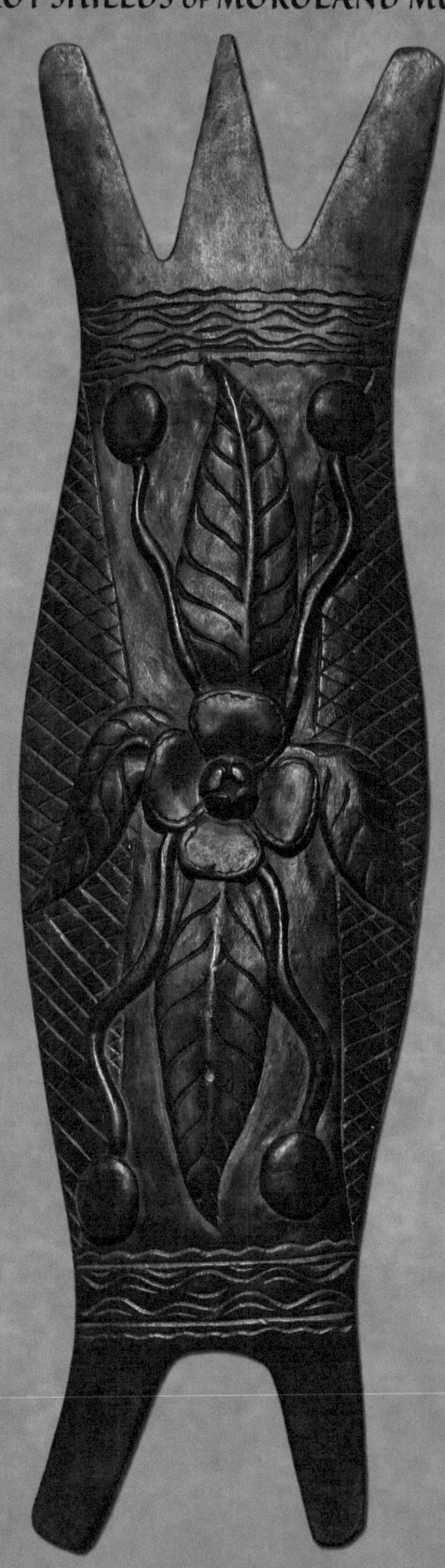

Igorot Shield: #09 Philippines Igorot Shields

IGOROT SHIELDS OF MOROLAND MUSEUM

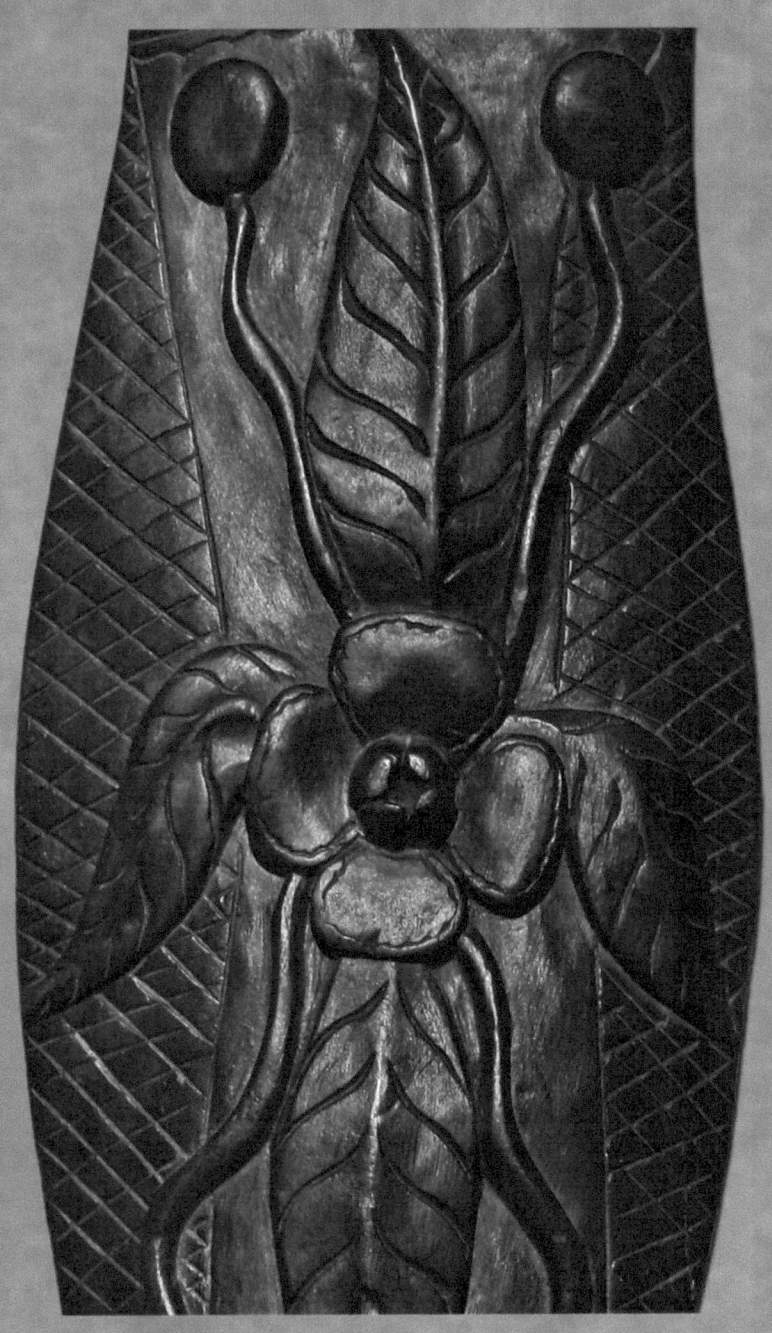

Igorot Shield: #09 Philippines Igorot Shields

Description:
 This is a vintage hand carved Philippines Ifugao, Igorot Bontoc Ceremonial Wooden Shield. This particular shield is referred to as a kalasag. It was created as a tourist piece for decoration or possibly used in a ceremony of some type. It has a beautiful flower (orchid?) carved on the front. This is a very rare pattern on these type of shields.

Location Found:	Manila, Philippines	**Length:**	27 inches
Location Purchased:	EBay	**Width:**	9.5 inches
Approximate Age:	1960's	**Condition:**	Museum Quality

IGOROT SHIELDS of MOROLAND MUSEUM

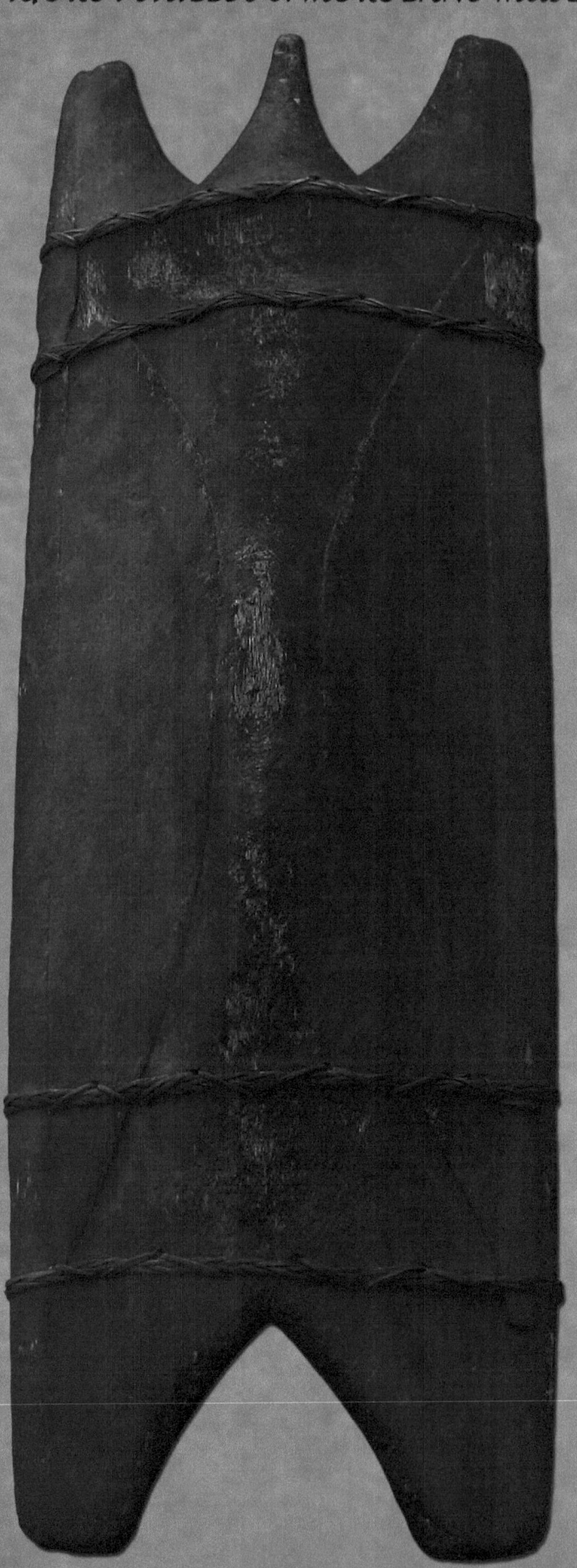

Igorot Shield: #10 Philippines Igorot Shields

IGOROT SHIELDS OF MOROLAND MUSEUM

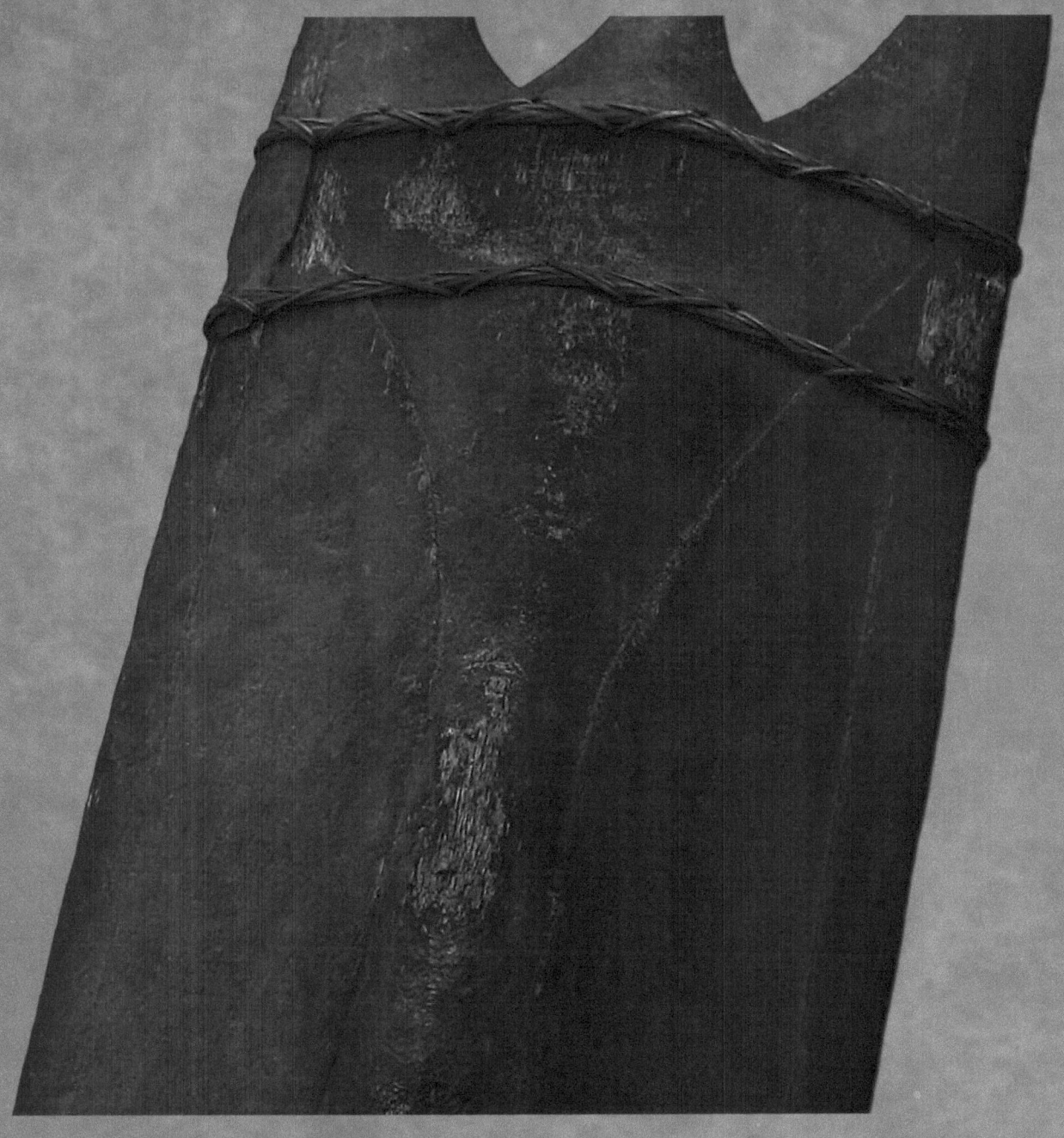

Igorot Shield: #10 Philippines Igorot Shields

Description:
 Igorot Ifugao Bontoc fighting shield, dark native wood, handmade with two rattan wrappings on top and bottom.

Location Found:	Manila, Philippines	**Length:**	40 inches
Location Purchased:	EBay	**Width:**	13.5 inches
Approximate Age:	1900's	**Condition:**	Above Average

IGOROT SHIELDS OF MOROLAND MUSEUM

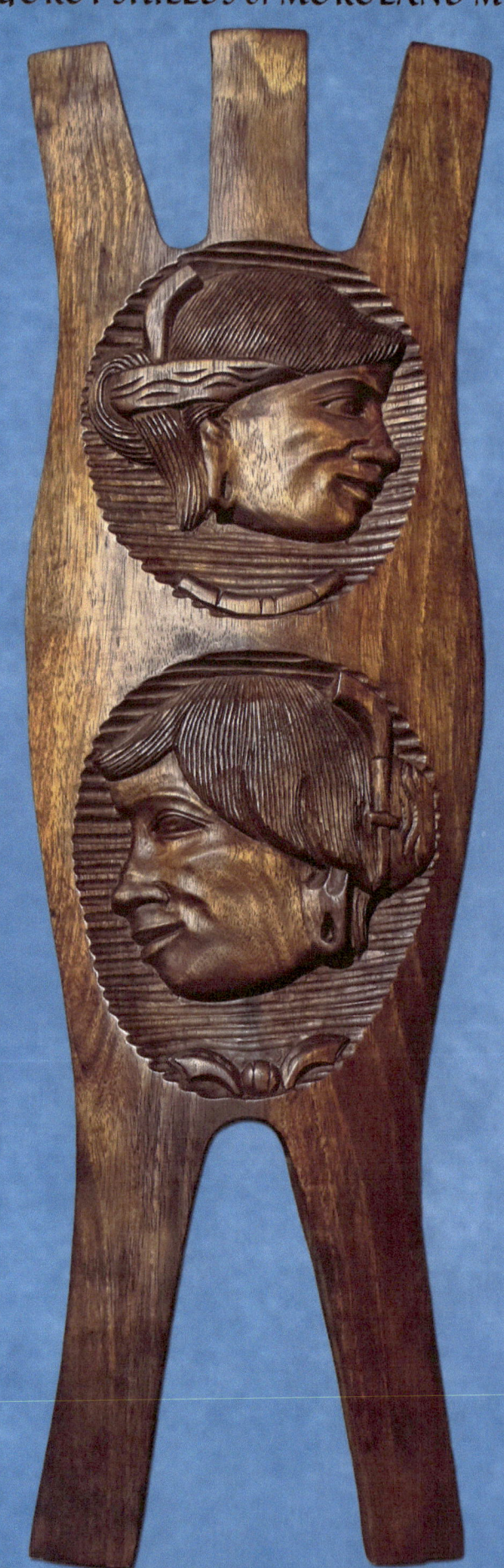

Igorot Shield: #11 Philippines Igorot Shields

IGOROT SHIELDS OF MOROLAND MUSEUM

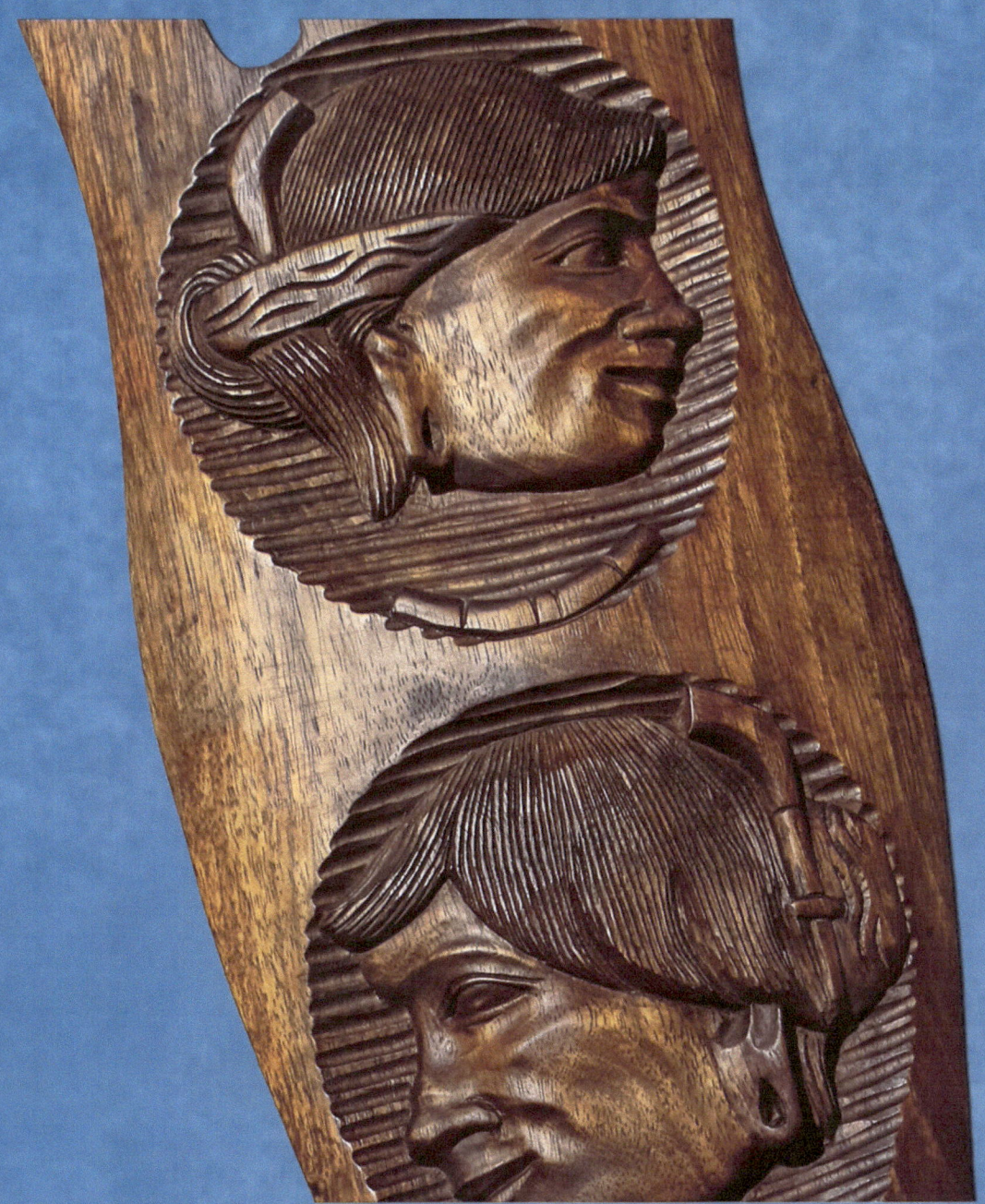

Igorot Shield: #11 Philippines Igorot Shields

Description:
 This is a vintage hand carved Philippines Ifugao, Igorot Bontoc Headhunter Ceremonial Wooden Shield. This particular shield is referred to as a kalasag. It was created as a tourist piece for decoration or possibly used in a ceremony of some type. It has two Igorot warrior heads on the front with tobacco pipes fashioned in the hair.

Location Found:	Luzon, Philippines	**Length:**	36 inches
Location Purchased:	EBay	**Width:**	12 inches
Approximate Age:	1970's	**Condition:**	Museum Quality

IGOROT SHIELDS OF MOROLAND MUSEUM

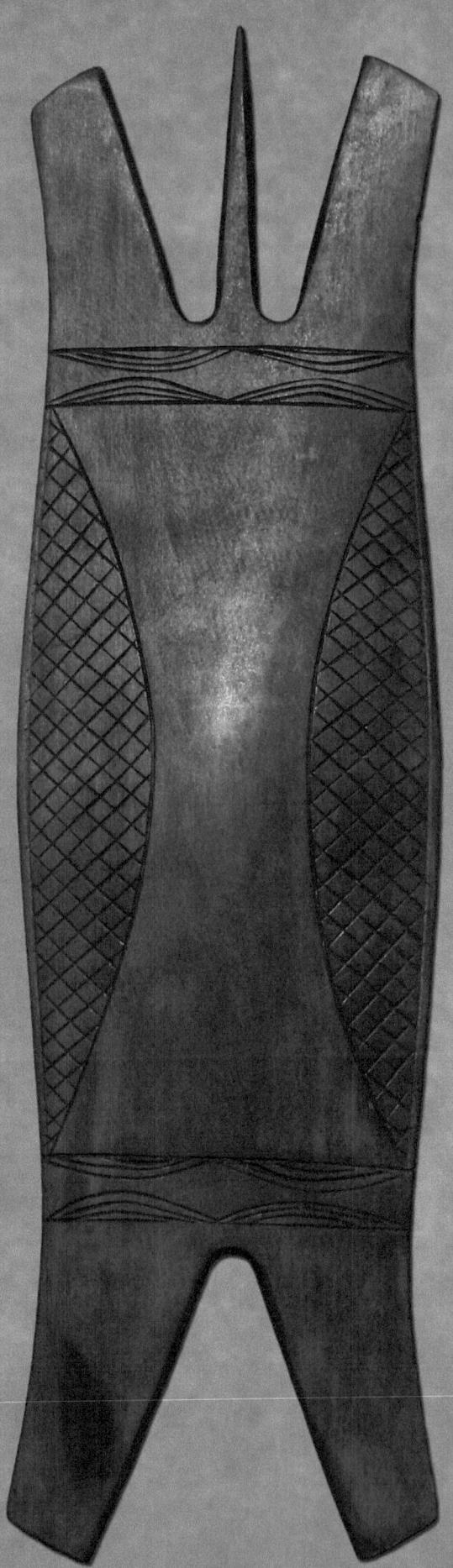

Igorot Shield: #12 Philippines Igorot Shields

IGOROT SHIELDS OF MOROLAND MUSEUM

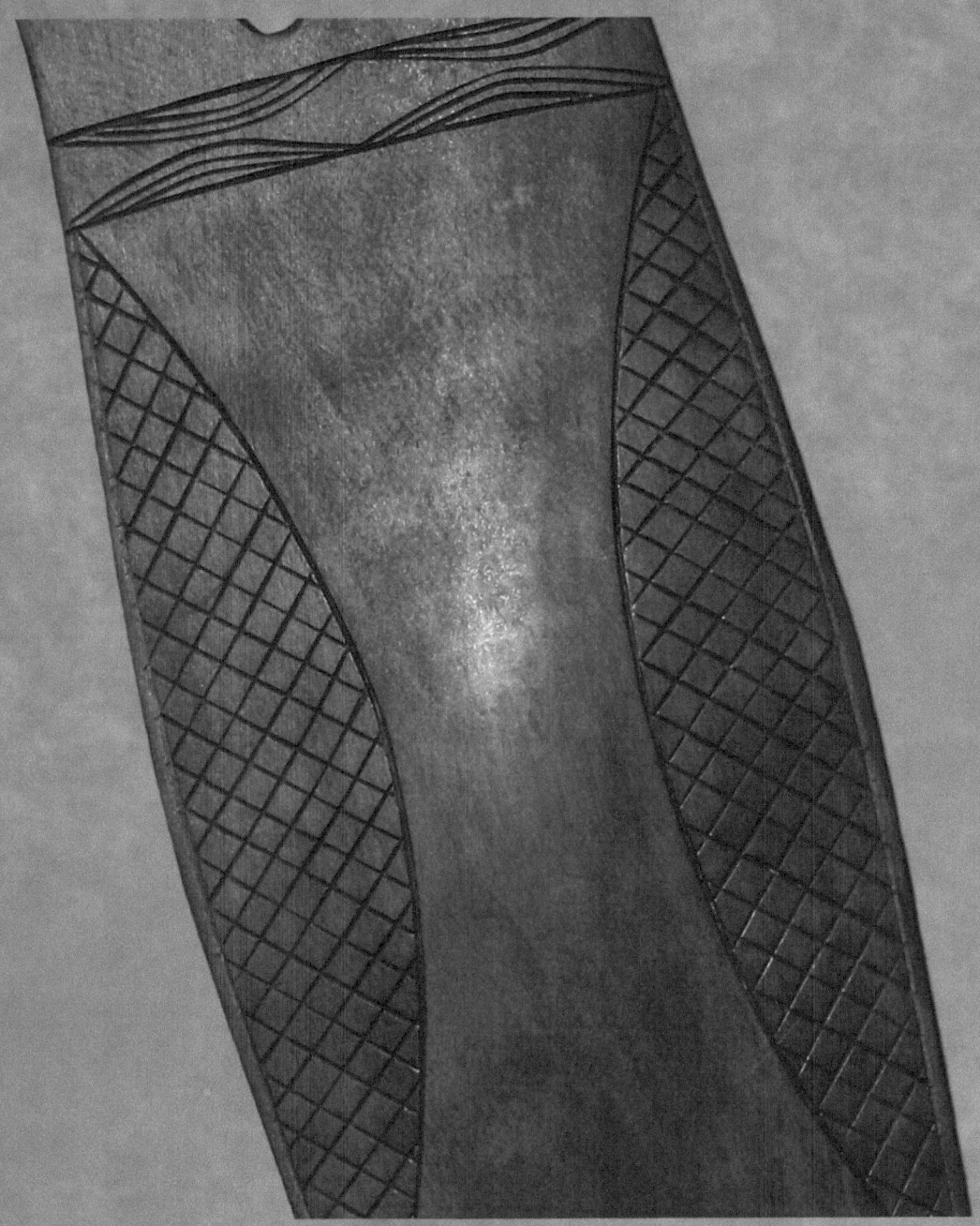

Igorot Shield: #12 Philippines Igorot Shields

Description:
 This is a vintage hand carved Philippines Ifugao, Igorot Bontoc Ceremonial Wooden Shield. This particular shield is referred to as a kalasag. It was created as a tourist piece for decoration or possibly used in a ceremony of some type.

Location Found:	Manila, Philippines	**Length:**	24 inches
Location Purchased:	EBay	**Width:**	7 inches
Approximate Age:	1970's	**Condition:**	Above Average

IGOROT SHIELDS OF MOROLAND MUSEUM

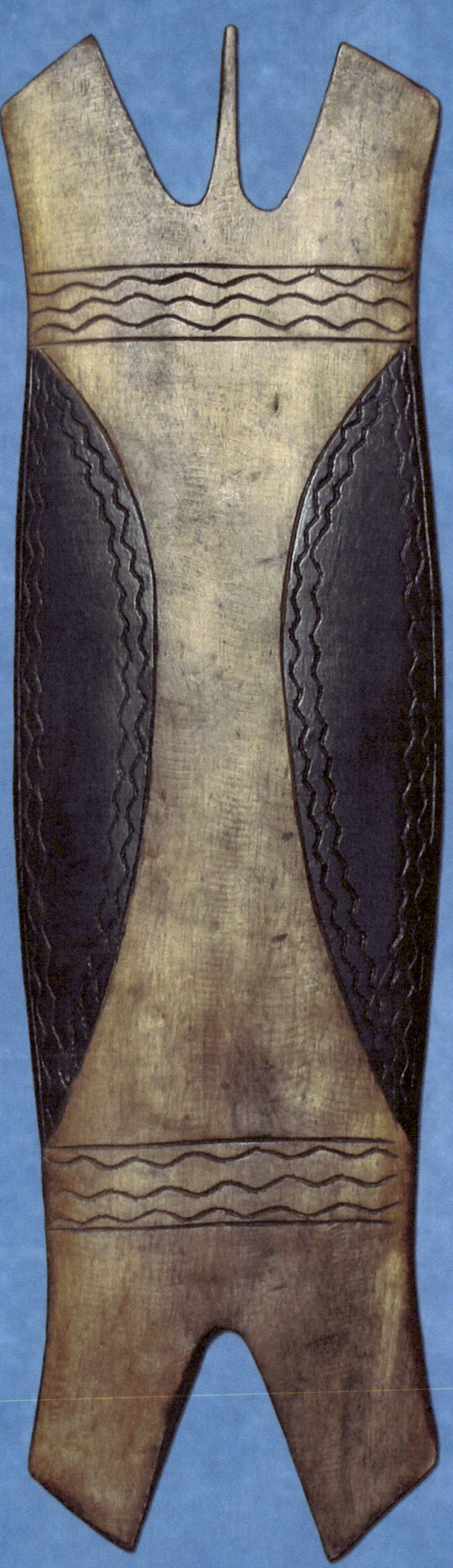

Igorot Shield: #13 Philippines Igorot Shields

IGOROT SHIELDS OF MOROLAND MUSEUM

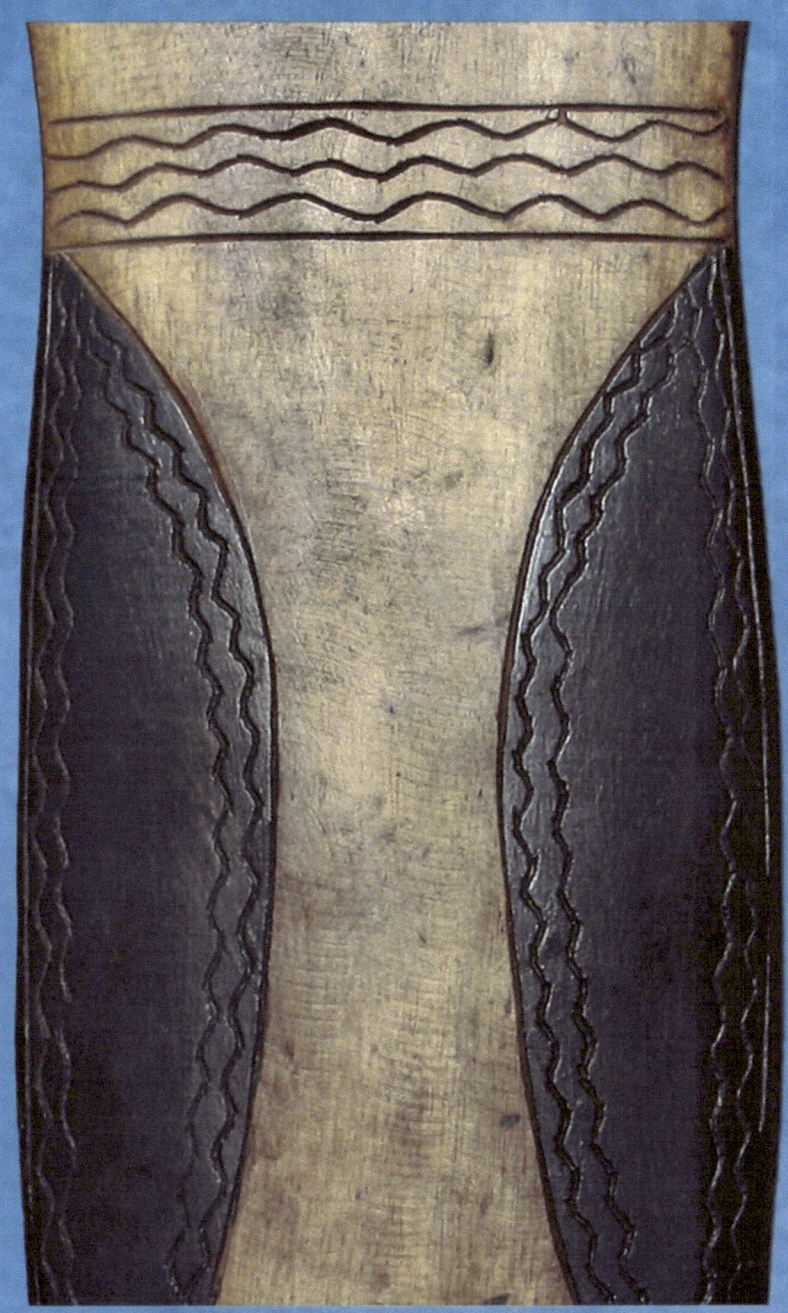

Igorot Shield: #13 Philippines Igorot Shields

Description:
 This is a vintage hand carved Philippines Ifugao, Igorot Bontoc Ceremonial Wooden Shield. This particular shield is referred to as a kalasag. It was created as a tourist piece for decoration or possibly used in a ceremony of some type.

Location Found:	Manila, Philippines	**Length:**	24 inches
Location Purchased:	EBay	**Width:**	7 inches
Approximate Age:	1970's	**Condition:**	Above Average

IGOROT SHIELDS of MOROLAND MUSEUM

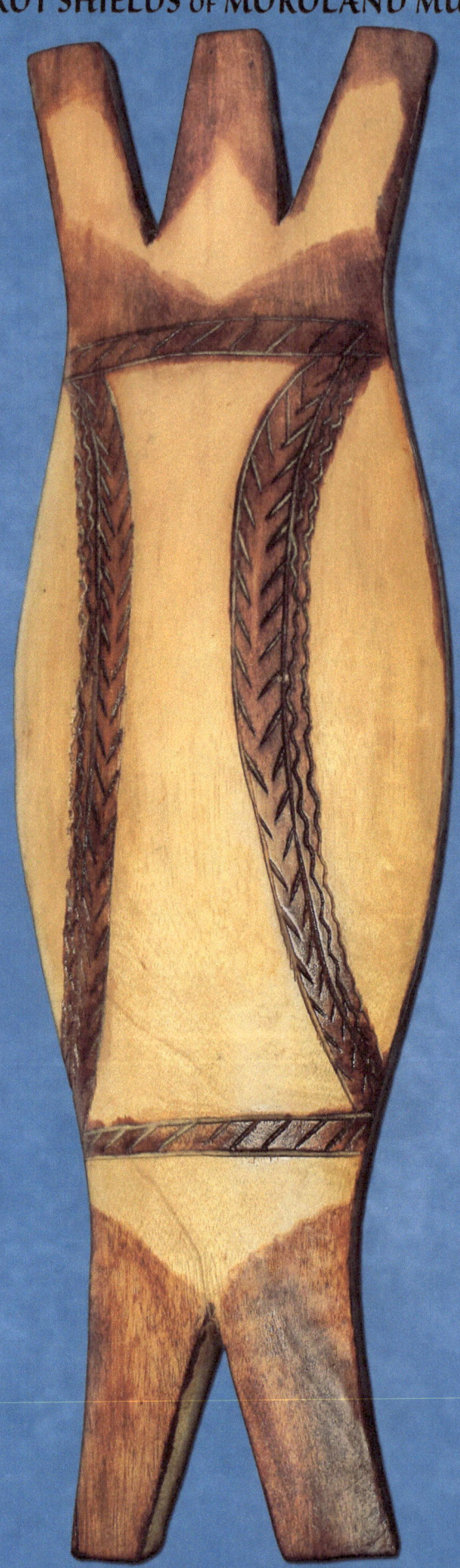

Igorot Shield: #14 Philippines Igorot Shields

IGOROT SHIELDS of MOROLAND MUSEUM

Igorot Shield: #14 Philippines Igorot Shields

Description:
 This is a vintage hand carved Philippines Ifugao, Igorot Bontoc Ceremonial Wooden Shield. This particular shield is referred to as a kalasag. It was created as a tourist piece for decoration or possibly used in a ceremony of some type.

Location Found:	Manila, Philippines	**Length:**	24 inches
Location Purchased:	EBay	**Width:**	7 inches
Approximate Age:	1970's	**Condition:**	Above Average

IGOROT SHIELDS OF MOROLAND MUSEUM

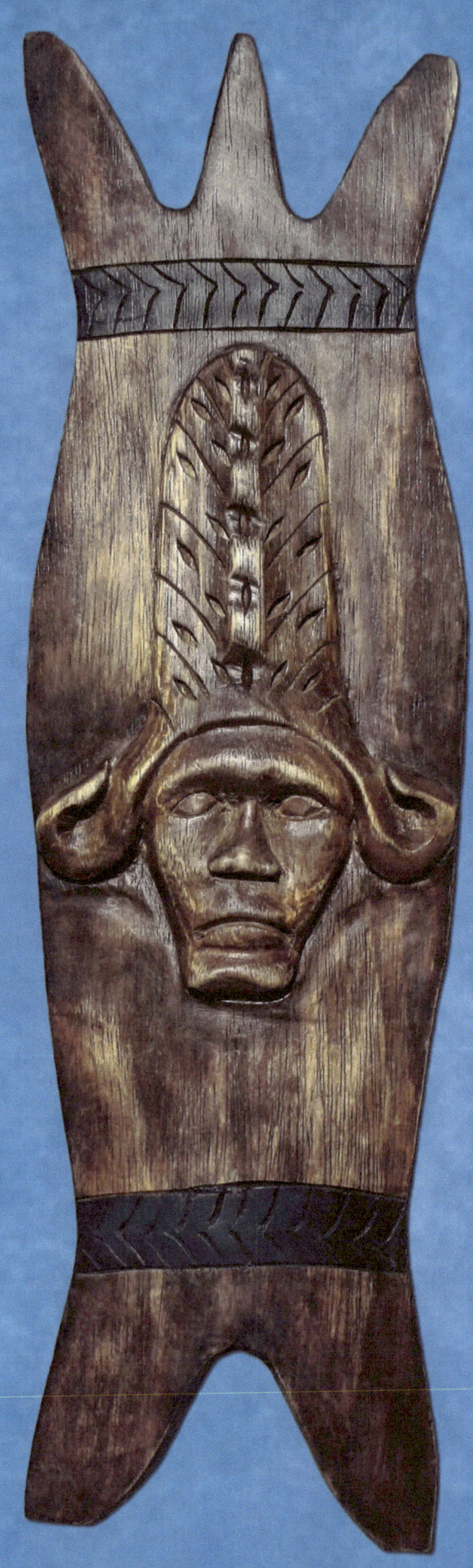

Igorot Shield: #15 Philippines Igorot Shields

IGOROT SHIELDS of MOROLAND MUSEUM

Igorot Shield: #15 Philippines Igorot Shields

Description:
 This is a vintage hand carved Philippines Ifugao, Igorot Bontoc Ceremonial Wooden Shield. This particular shield is referred to as a kalasag. It was created as a tourist piece for decoration or possibly used in a ceremony of some type. It has a warrior head carved on the front with a ceremonial crown on top. It has two carved dark bands on the top and bottom of the shield.

Location Found:	Manila, Philippines	**Length:**	27 inches
Location Purchased:	EBay	**Width:**	9.5 inches
Approximate Age:	1950's	**Condition:**	Museum Quality

IGOROT SHIELDS of MOROLAND MUSEUM

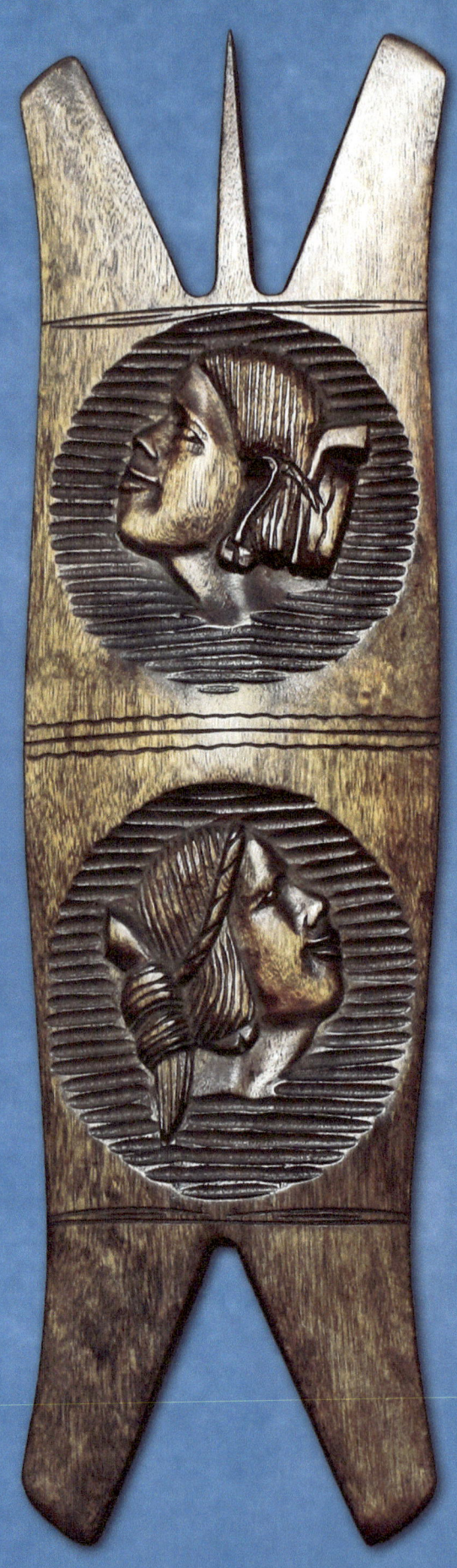

Igorot Shield: #16 Philippines Igorot Shields

IGOROT SHIELDS OF MOROLAND MUSEUM

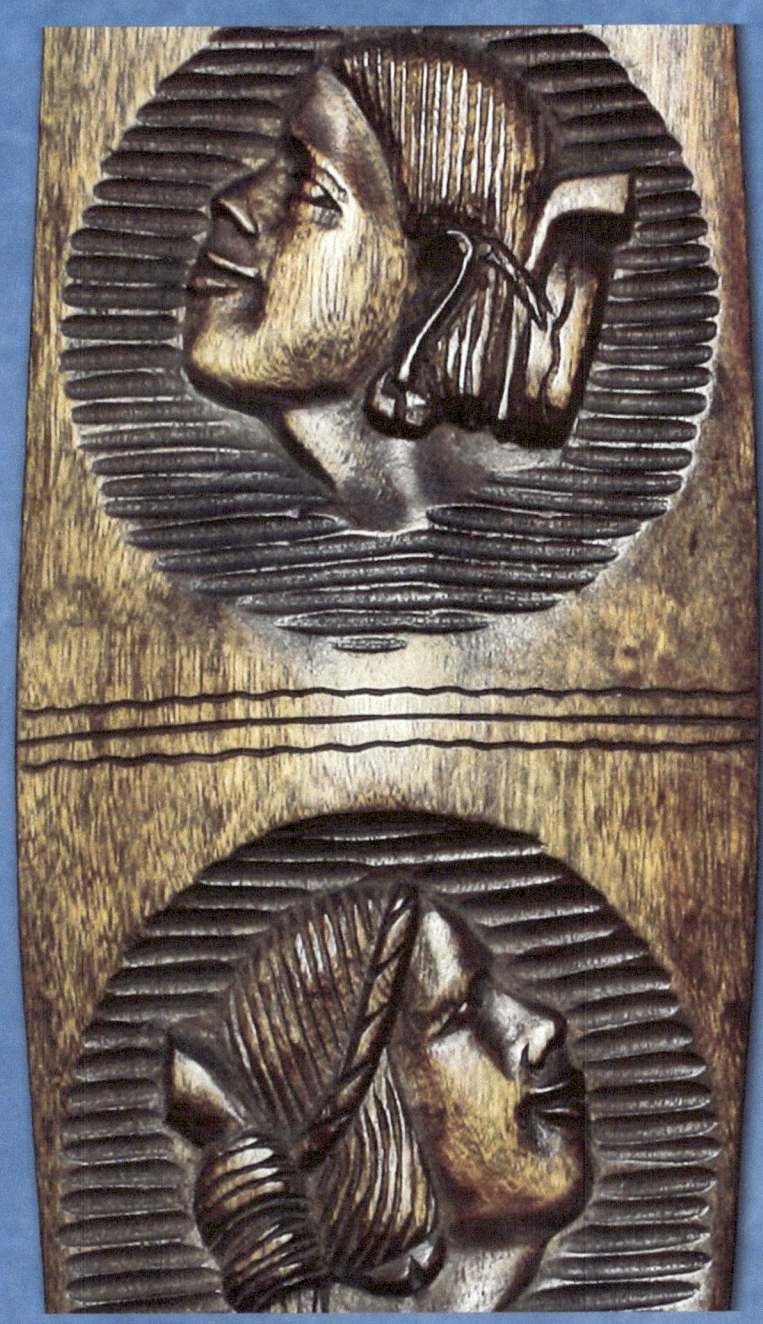

Igorot Shield: #16 Philippines Igorot Shields

Description:

This is a vintage hand carved Philippines Ifugao, Igorot Bontoc Ceremonial Wooden Shield. This particular shield is referred to as a kalasag. It was created as a tourist piece for decoration or possibly used in a ceremony of some type. It has two Igorot warrior heads carved on the front with tobacco pipes fashioned in the hair. It has two unique necklace patterns carved in the wood around each warriors head.

Location Found:	Manila, Philippines	**Length:**	24 inches
Location Purchased:	EBay	**Width:**	7.5 inches
Approximate Age:	1980's	**Condition:**	Museum Quality

IGOROT SHIELDS of MOROLAND MUSEUM

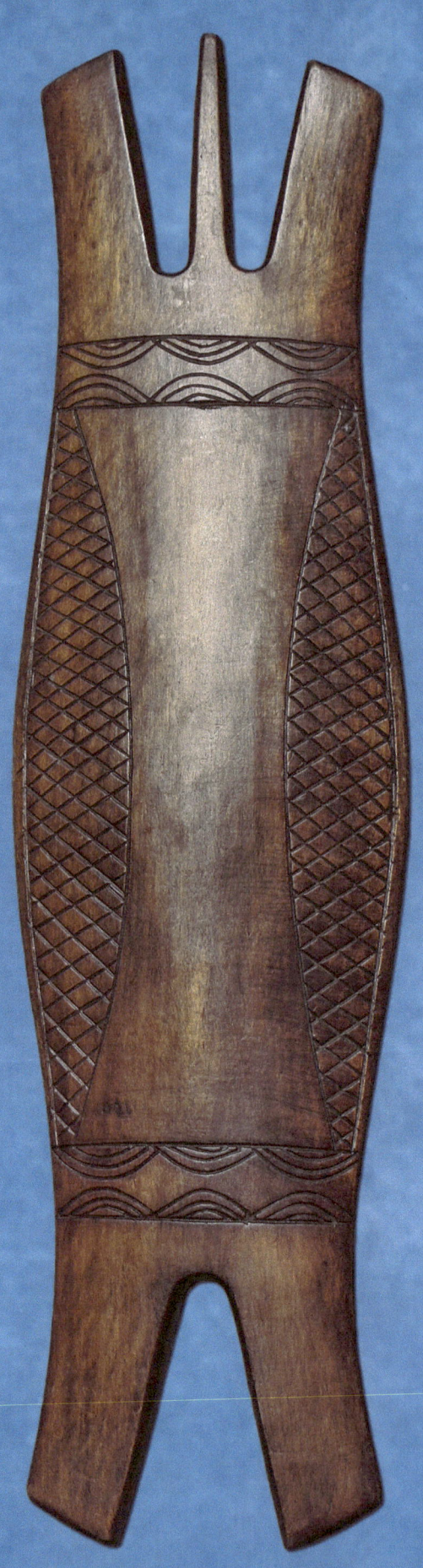

40 Igorot Shield: #17 Philippines Igorot Shields

IGOROT SHIELDS OF MOROLAND MUSEUM

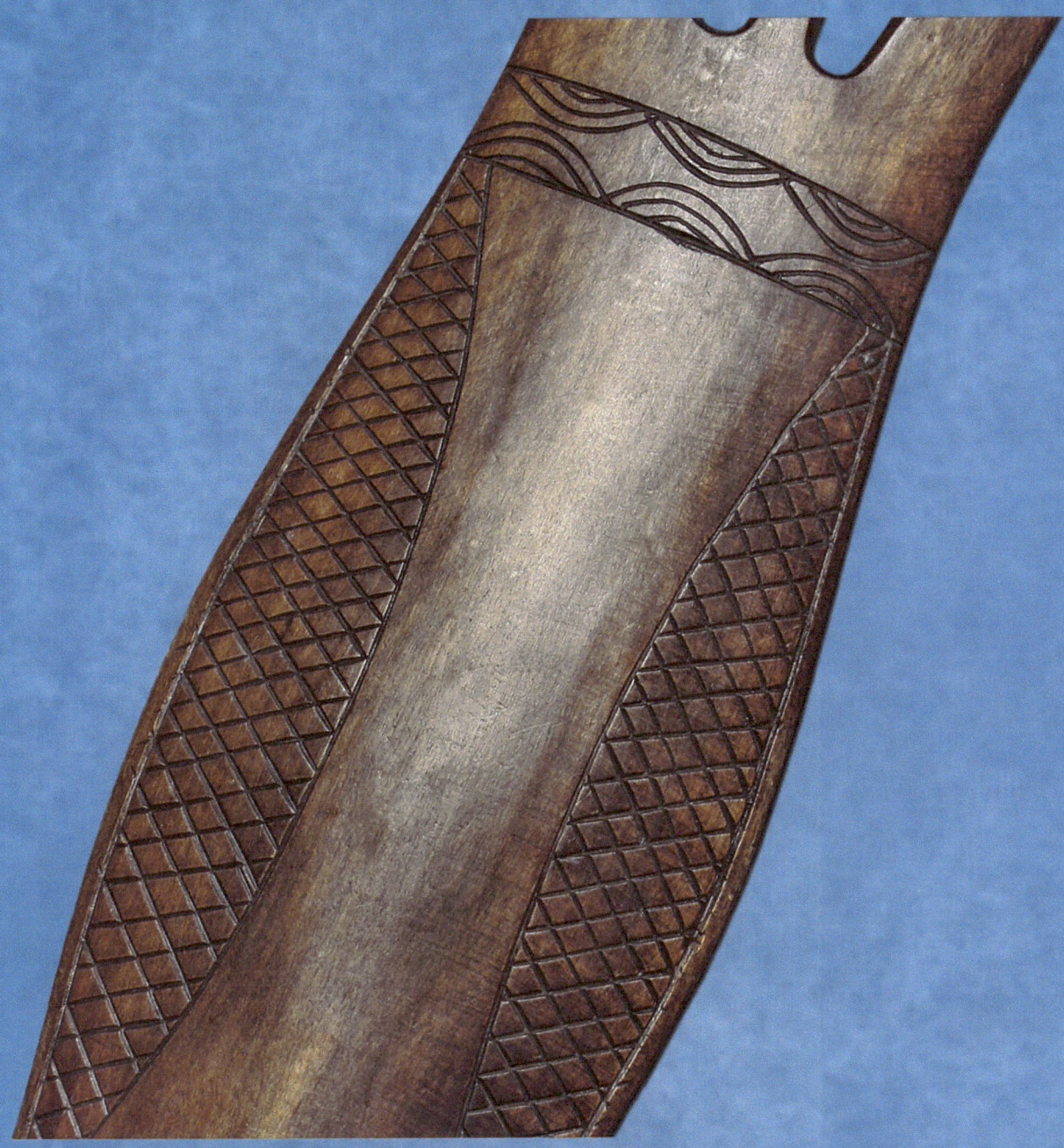

Igorot Shield: #17 Philippines Igorot Shields

Description:
This is a vintage hand carved Philippines Ifugao, Igorot Bontoc Ceremonial Wooden Shield. This particular shield is referred to as a kalasag. It was created as a tourist piece for decoration or possibly used in a ceremony of some type.

Location Found:	Manila, Philippines	**Length:**	24 inches
Location Purchased:	EBay	**Width:**	7 inches
Approximate Age:	1970's	**Condition:**	Above Average

IGOROT SHIELDS OF MOROLAND MUSEUM

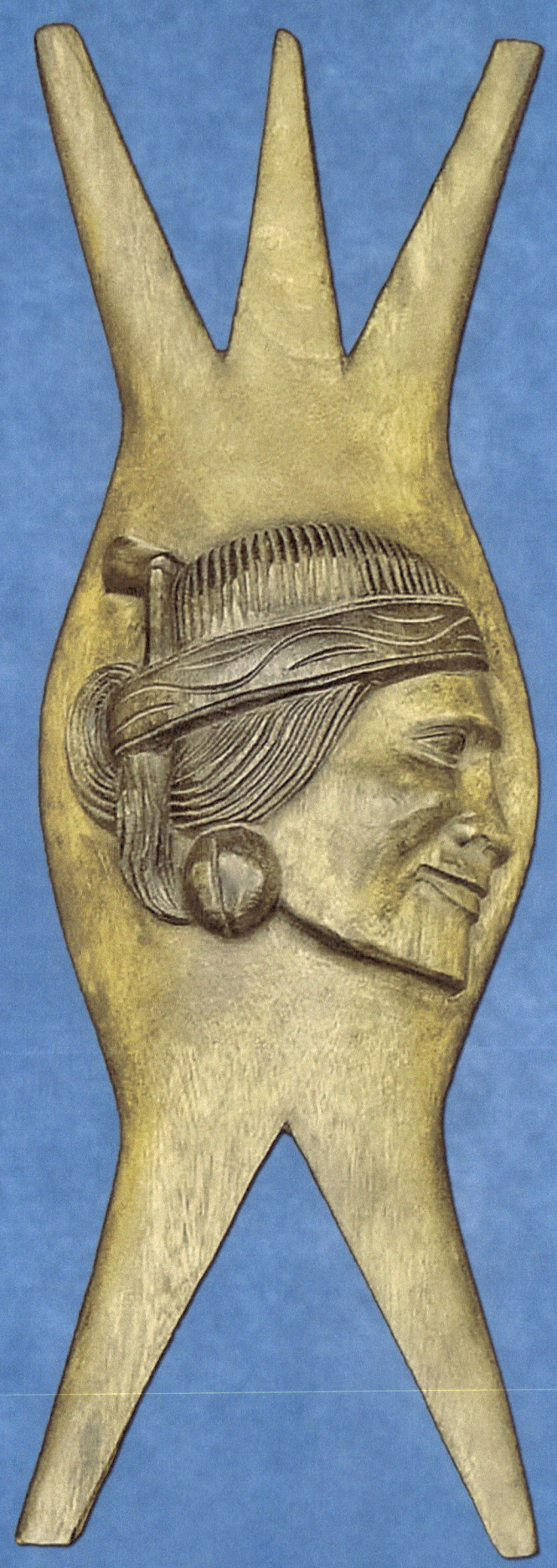

42　　　　　　　　　　　　　　　　　　　　**Igorot Shield:** #18 Philippines Igorot Shields

IGOROT SHIELDS of MOROLAND MUSEUM

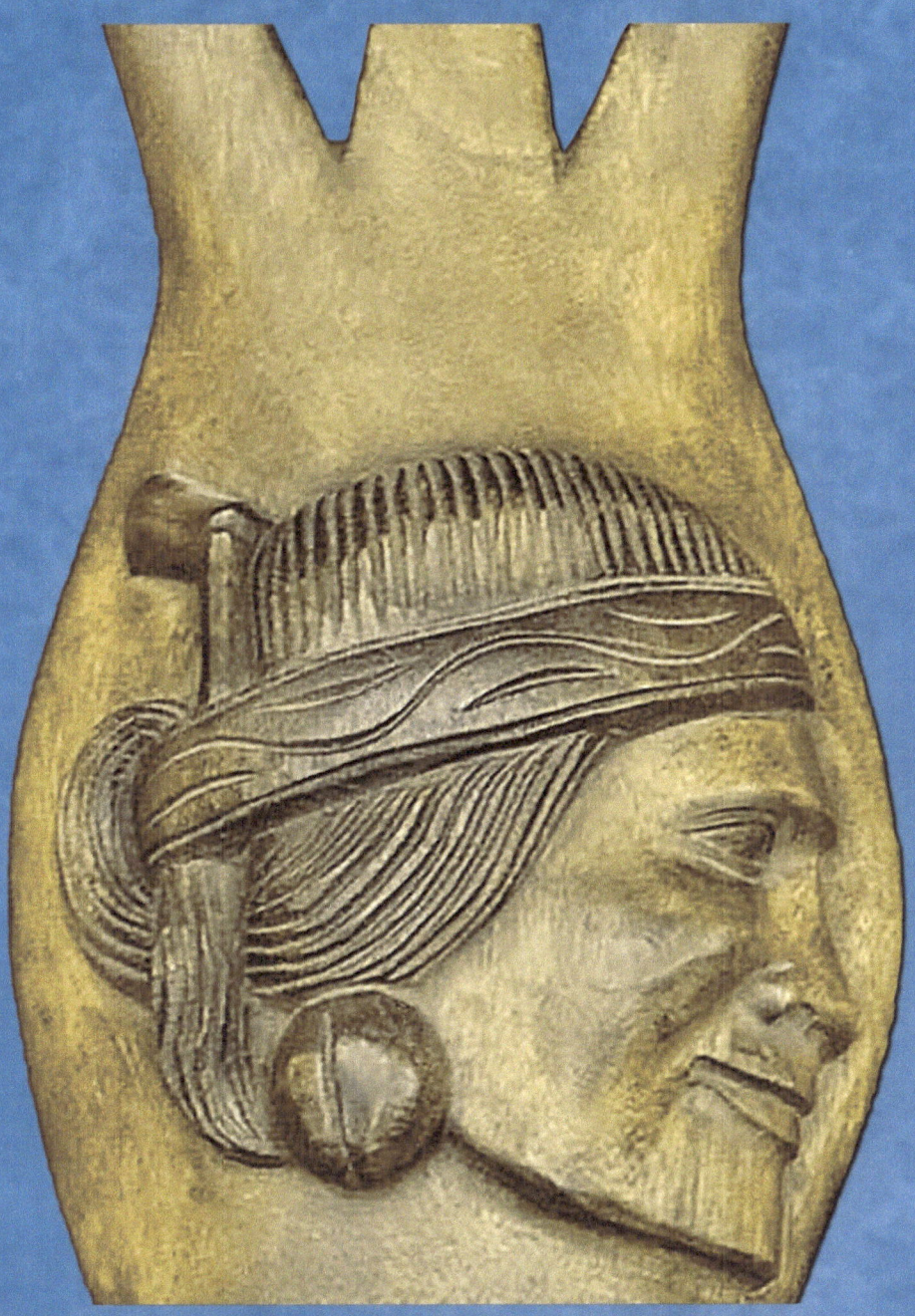

Igorot Shield: #18 Philippines Igorot Shields

Description:
 This is a small vintage hand carved Philippines Ifugao, Igorot Bontoc Ceremonial Wooden Shield. This particular shield is referred to as a kalasag. It was created as a tourist piece for decoration or possibly used in a ceremony of some type. It has one Igorot warrior head carved on the front with a tobacco pipe fashioned in the hair.

Location Found:	Manila, Philippines	**Length:**	13 inches
Location Purchased:	EBay	**Width:**	6 inches
Approximate Age:	1970's	**Condition:**	Museum Quality

IGOROT SHIELDS OF MOROLAND MUSEUM

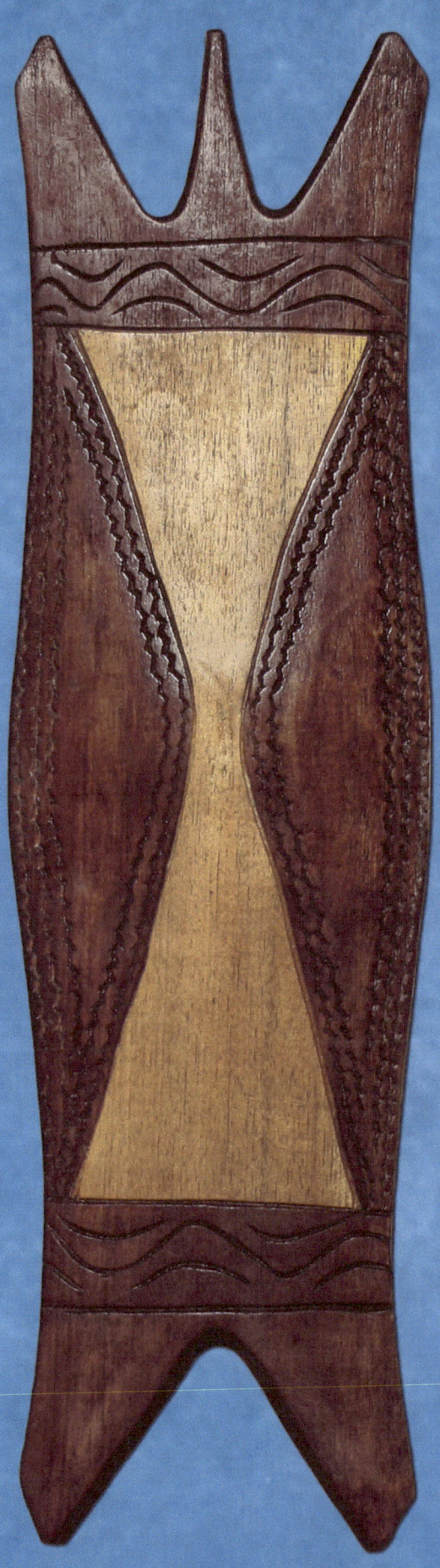

Igorot Shield: #19 Philippines Igorot Shields

IGOROT SHIELDS OF MORELAND MUSEUM

Igorot Shield: #19 Philippines Igorot Shields

Description:
 This is a vintage hand carved Philippines Ifugao, Igorot Bontoc Ceremonial Wooden Shield. This particular shield is referred to as a kalasag. It was created as a tourist piece for decoration or possibly used in a ceremony of some type.

Location Found:	Manila, Philippines	**Length:**	24 inches
Location Purchased:	EBay	**Width:**	7 inches
Approximate Age:	1970's	**Condition:**	Above Average

IGOROT SHIELDS OF MOROLAND MUSEUM

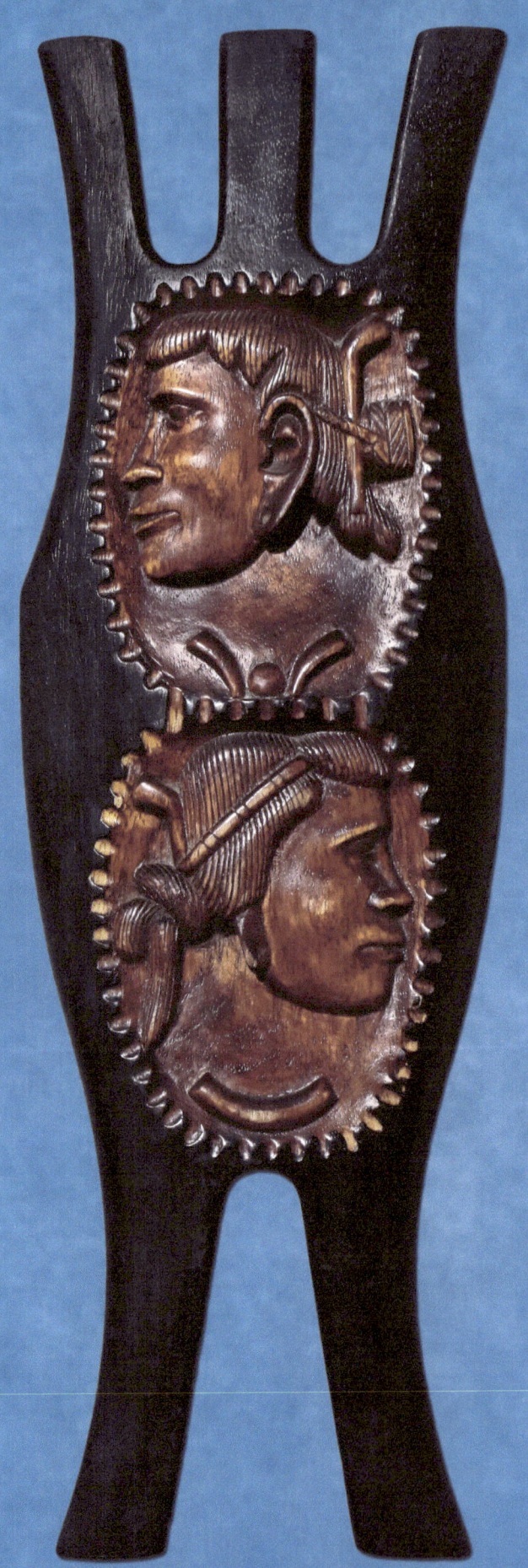

Igorot Shield: #20 Philippines Igorot Shields

IGOROT SHIELDS of MOROLAND MUSEUM

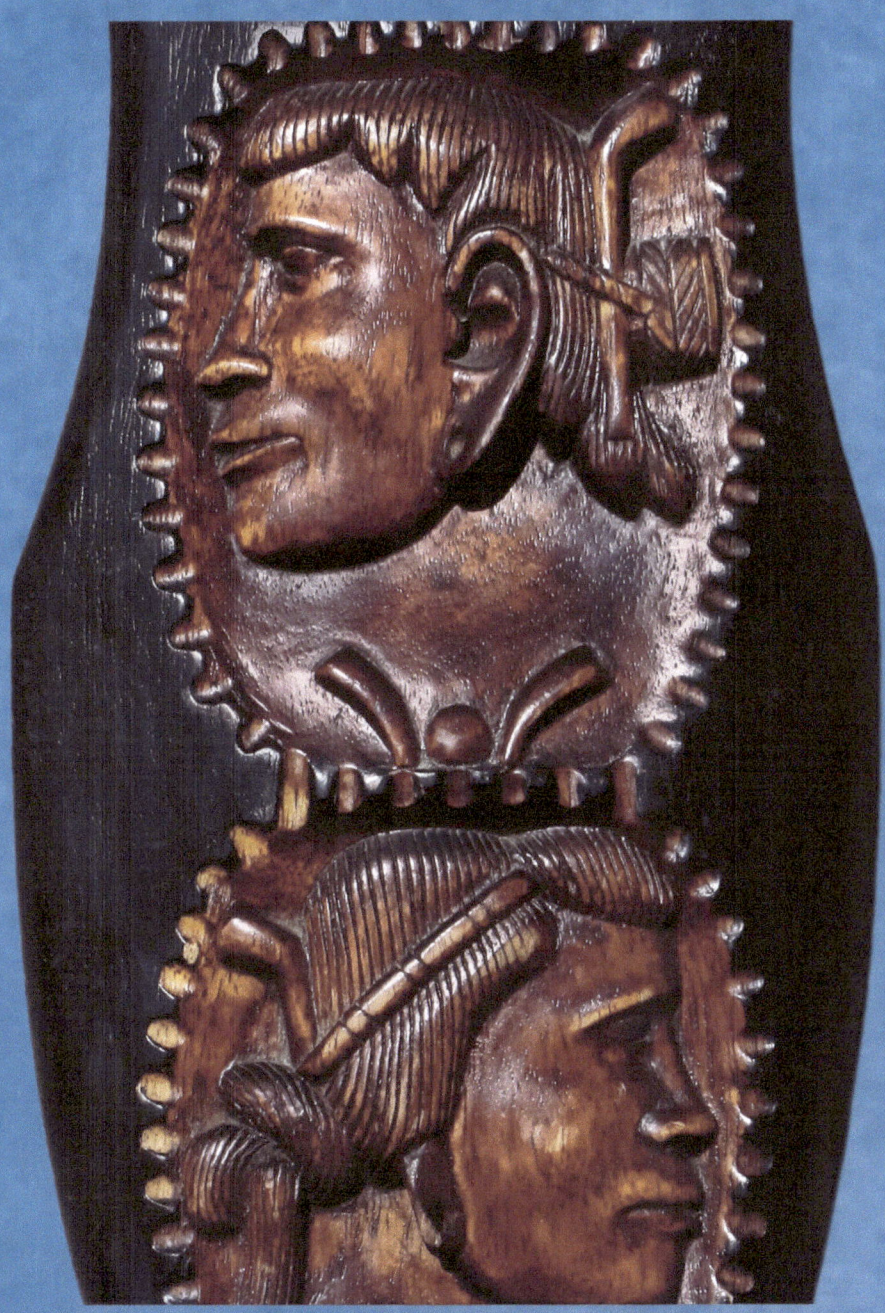

Igorot Shield: #20 Philippines Igorot Shields

Description:
 This is a vintage hand carved Philippines Ifugao, Igorot Bontoc Ceremonial Wooden Shield. This particular shield is referred to as a kalasag. It was created as a tourist piece for decoration or possibly used in a ceremony of some type. It has two Igorot warrior heads carved on the front with tobacco pipes fashioned in the hair. It is stained with two different colors. It has two unique necklace patterns carved in the wood around each warriors head.

Location Found:	Luzon, Philippines	**Length:**	24 inches
Location Purchased:	EBay	**Width:**	7.5 inches
Approximate Age:	1980's	**Condition:**	Museum Quality

IGOROT SHIELDS OF MOROLAND MUSEUM

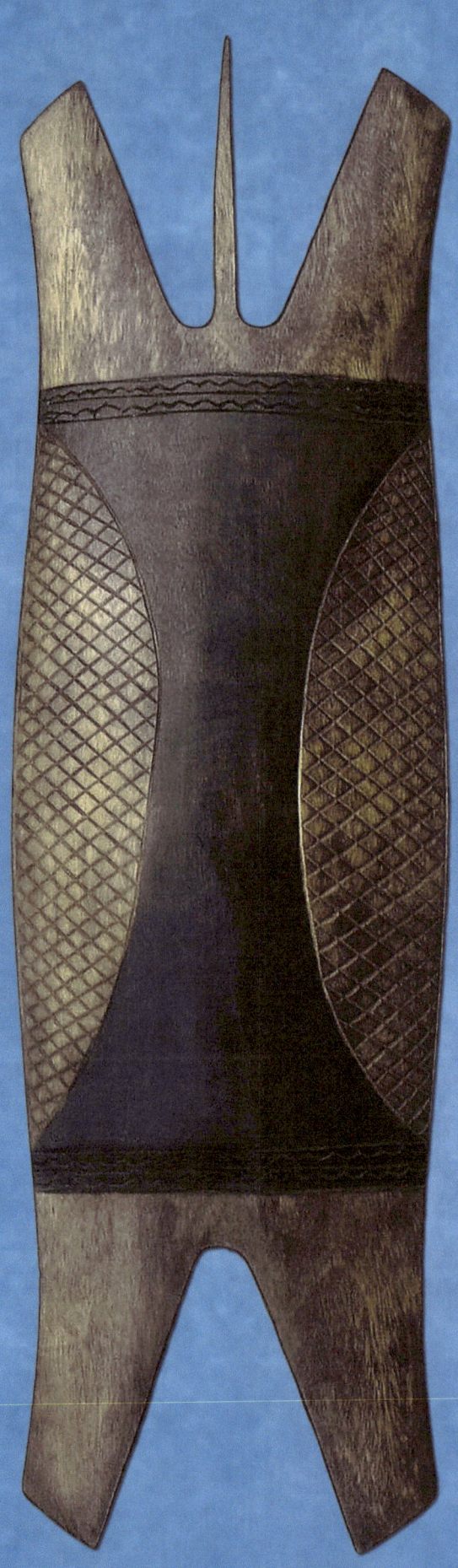

Igorot Shield: #21 Philippines Igorot Shields

IGOROT SHIELDS of MOROLAND MUSEUM

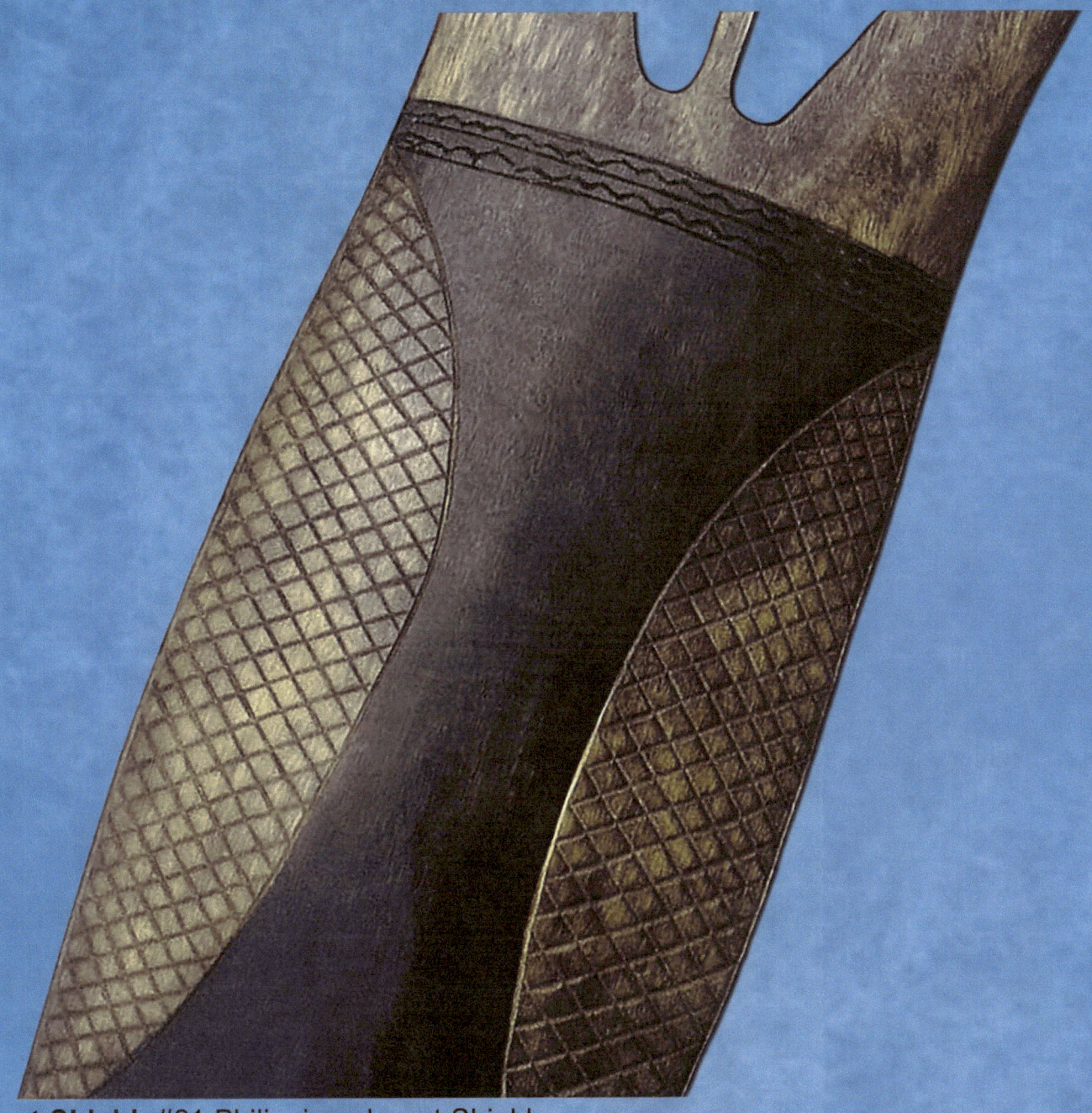

Igorot Shield: #21 Philippines Igorot Shields

Description:
 This is a vintage hand carved Philippines Ifugao, Igorot Bontoc Ceremonial Wooden Shield. This particular shield is referred to as a kalasag. It was created as a tourist piece for decoration or possibly used in a ceremony of some type.

Location Found:	Manila, Philippines	**Length:**	24 inches
Location Purchased:	EBay	**Width:**	7 inches
Approximate Age:	1960's	**Condition:**	Above Average

IGOROT SHIELDS OF MOROLAND MUSEUM

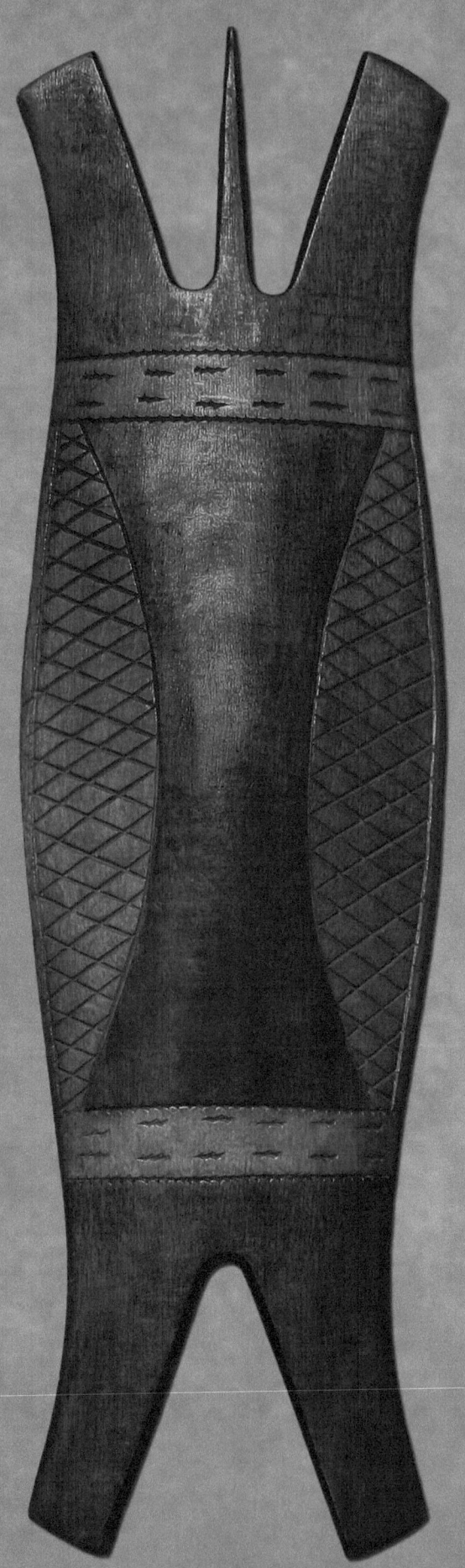

50 **Igorot Shield:** #22 Philippines Igorot Shields

IGOROT SHIELDS OF MOROLAND MUSEUM

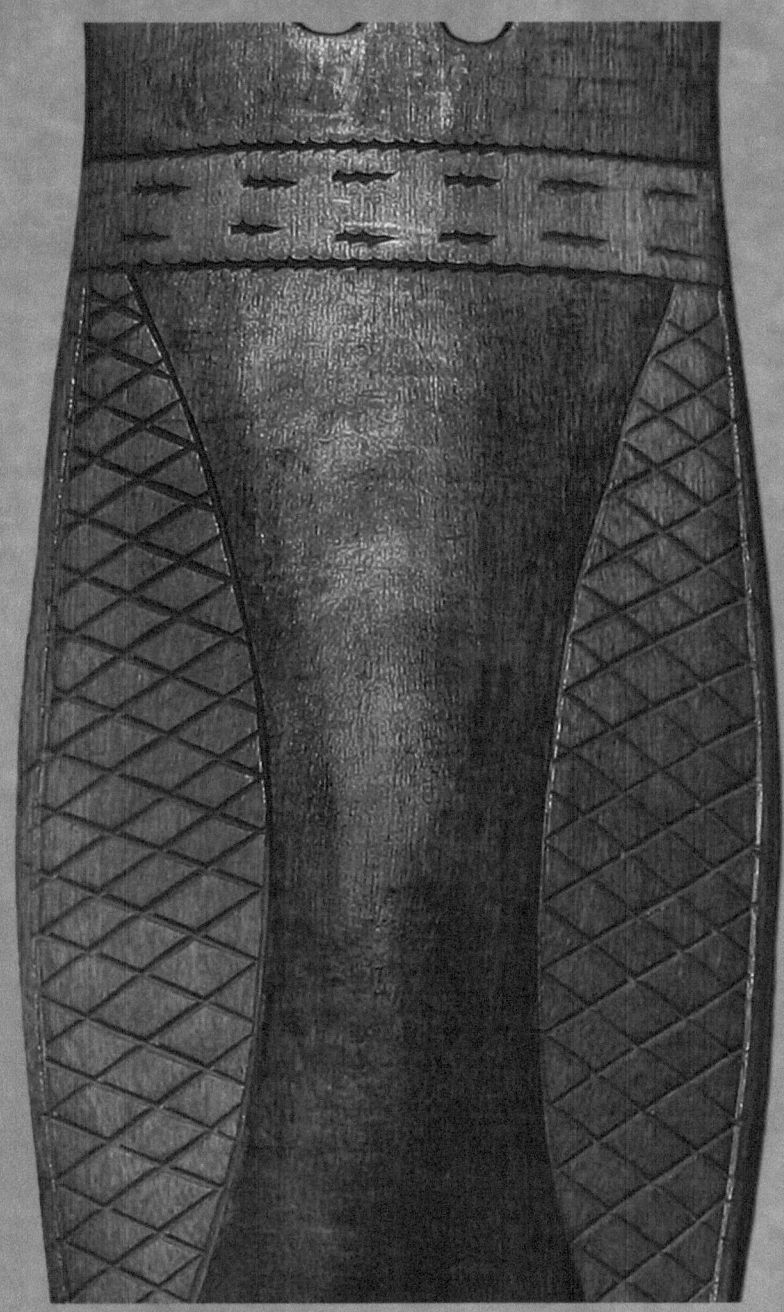

Igorot Shield: #22 Philippines Igorot Shields

Description:
 This is a vintage hand carved Philippines Ifugao, Igorot Bontoc Ceremonial Wooden Shield. This particular shield is referred to as a kalasag. It was created as a tourist piece for decoration or possibly used in a ceremony of some type.

Location Found:	Manila, Philippines	**Length:**	24 inches
Location Purchased:	EBay	**Width:**	7 inches
Approximate Age:	1970's	**Condition:**	Above Average

IGOROT SHIELDS OF MOROLAND MUSEUM

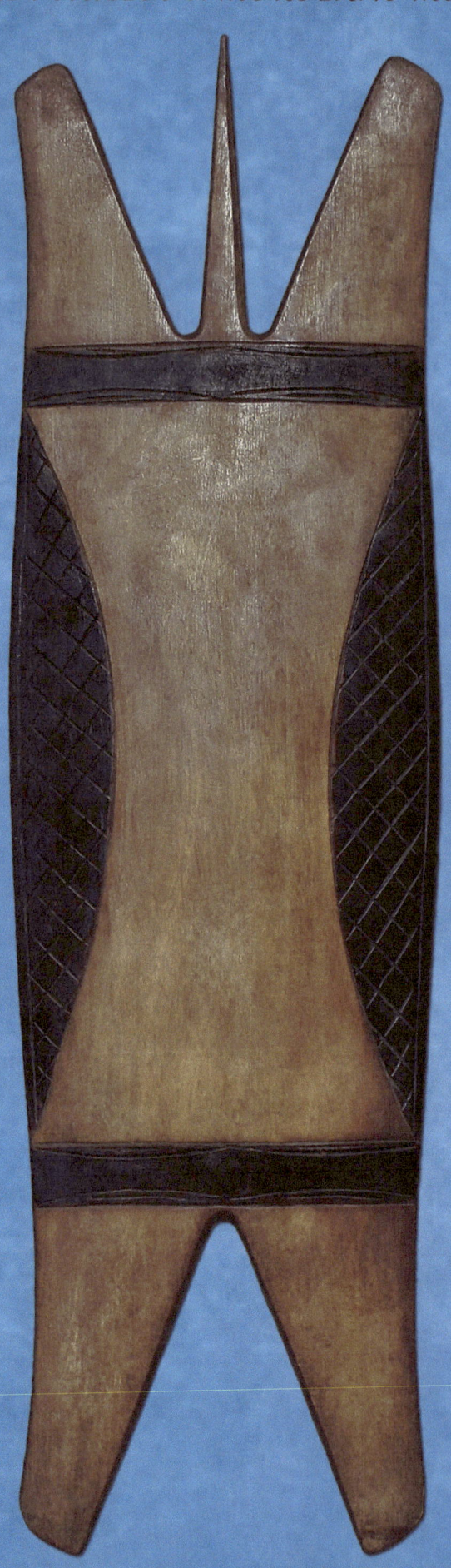

Igorot Shield: #23 Philippines Igorot Shields

IGOROT SHIELDS OF MOROLAND MUSEUM

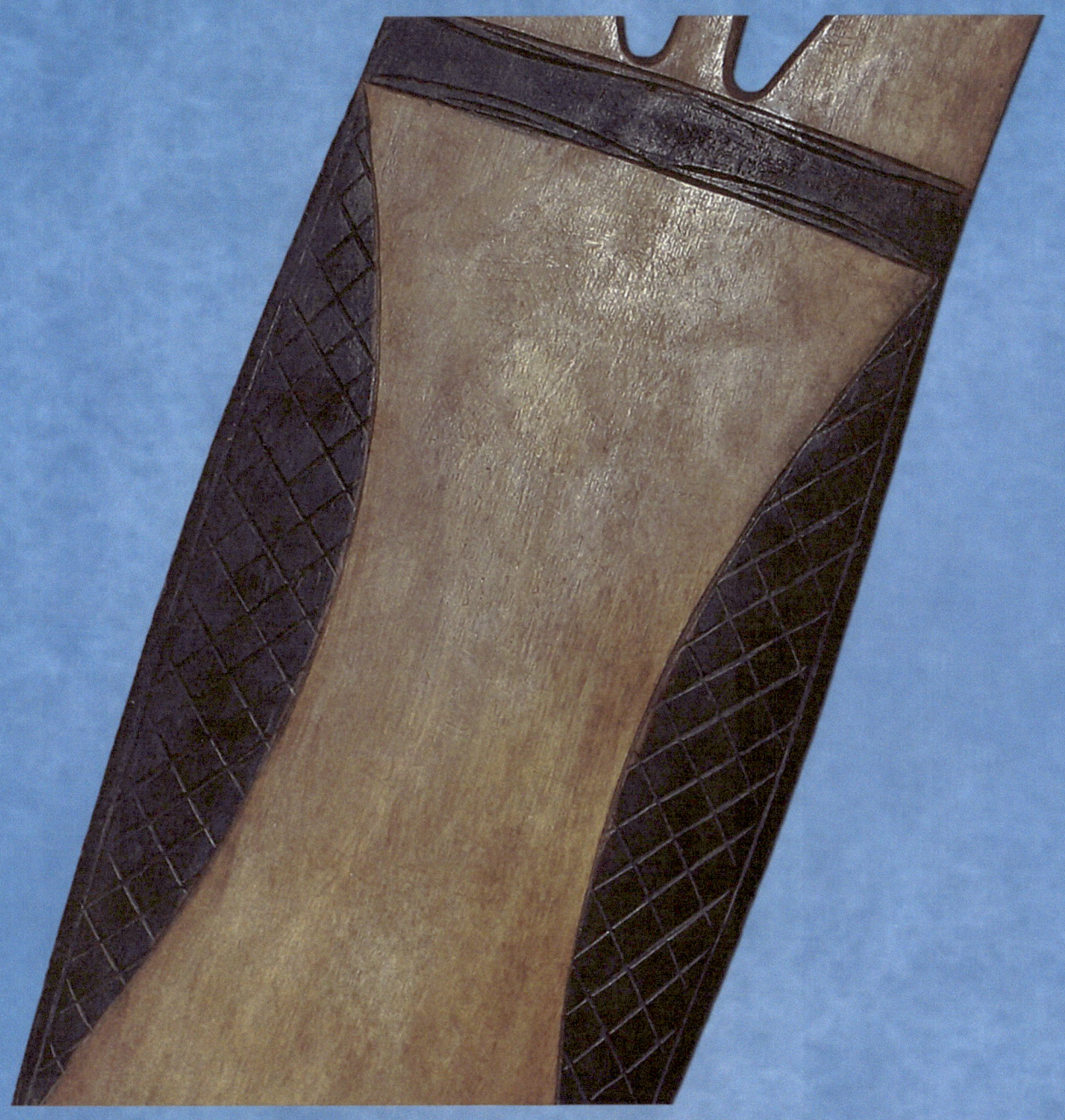

Igorot Shield: #23 Philippines Igorot Shields

Description:

This is a vintage hand carved Philippines Ifugao, Igorot Bontoc Ceremonial Wooden Shield. This particular shield is referred to as a kalasag. It was created as a tourist piece for decoration or possibly used in a ceremony of some type.

Location Found:	Manila, Philippines	**Length:**	24 inches
Location Purchased:	EBay	**Width:**	7 inches
Approximate Age:	1970's	**Condition:**	Above Average

IGOROT SHIELDS OF MOROLAND MUSEUM

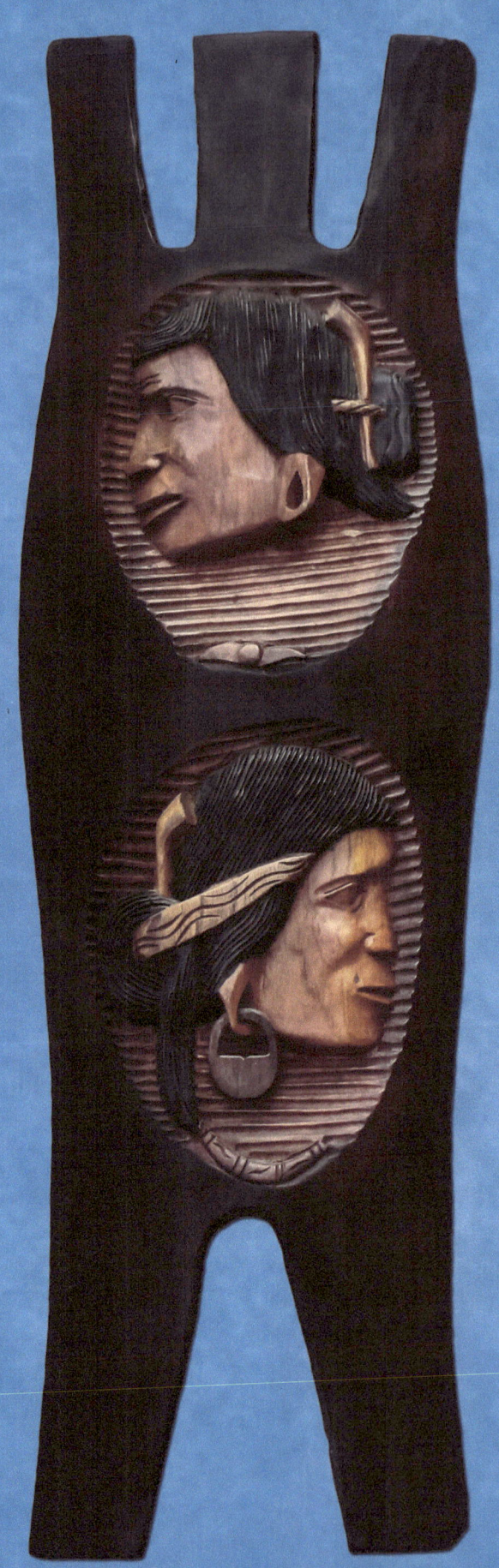

Igorot Shield: #24 Philippines Igorot Shields

IGOROT SHIELDS of MOROLAND MUSEUM

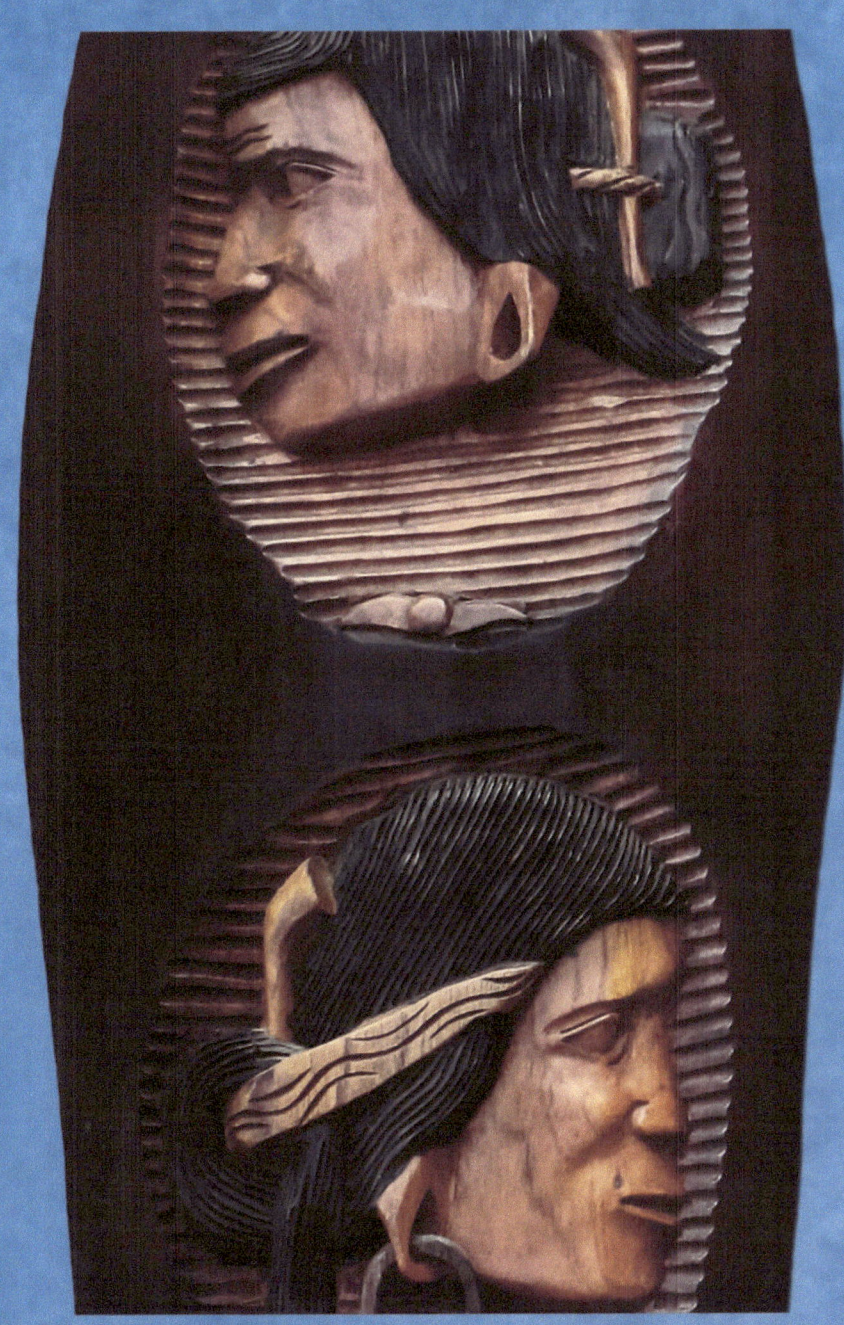

Igorot Shield: #24 Philippines Igorot Shields

Description:
 This is a vintage hand carved Philippines Bontoc,Igorot ceremonial warrior Shield. This particular shield is referred to as a kalasag. Most likely a souvenir piece. It is based on the Isneg-Apayao tribe, in the North Luzon region of the Philippines. It has two Igorot warrior heads on the front with tobacco pipes fashioned in the hair. It is stained in multiple colors.

Location Found:	Cebu, Philippines	**Length:**	37.5 inches
Location Purchased:	EBay	**Width:**	11.5 inches
Approximate Age:	1960's	**Condition:**	Museum Quality

IGOROT SHIELDS OF MOROLAND MUSEUM

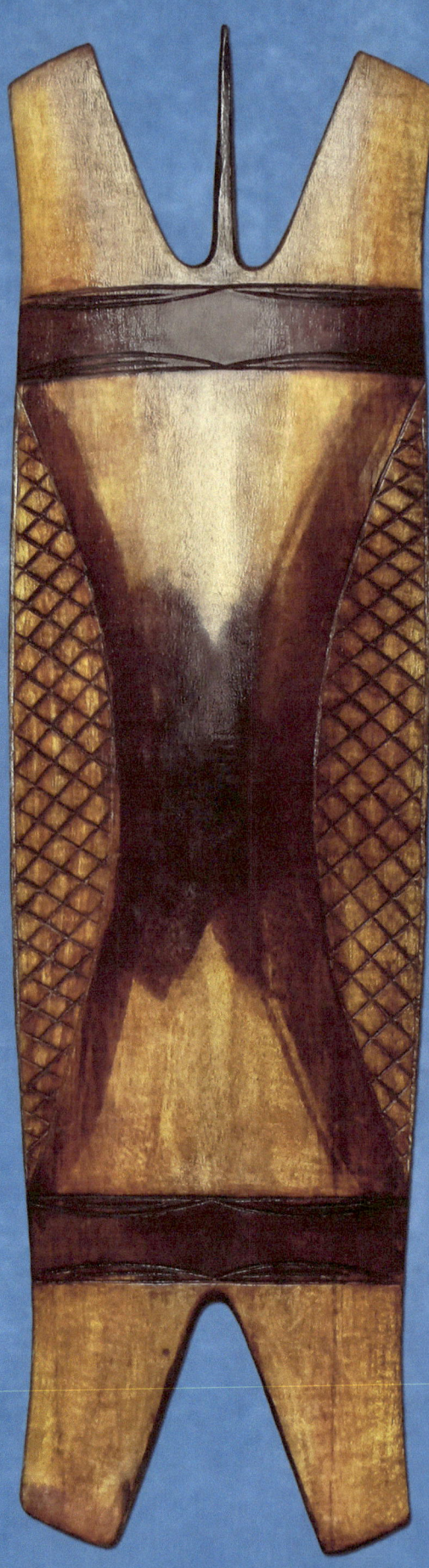

Igorot Shield: #25 Philippines Igorot Shields

IGOROT SHIELDS OF MOROLAND MUSEUM

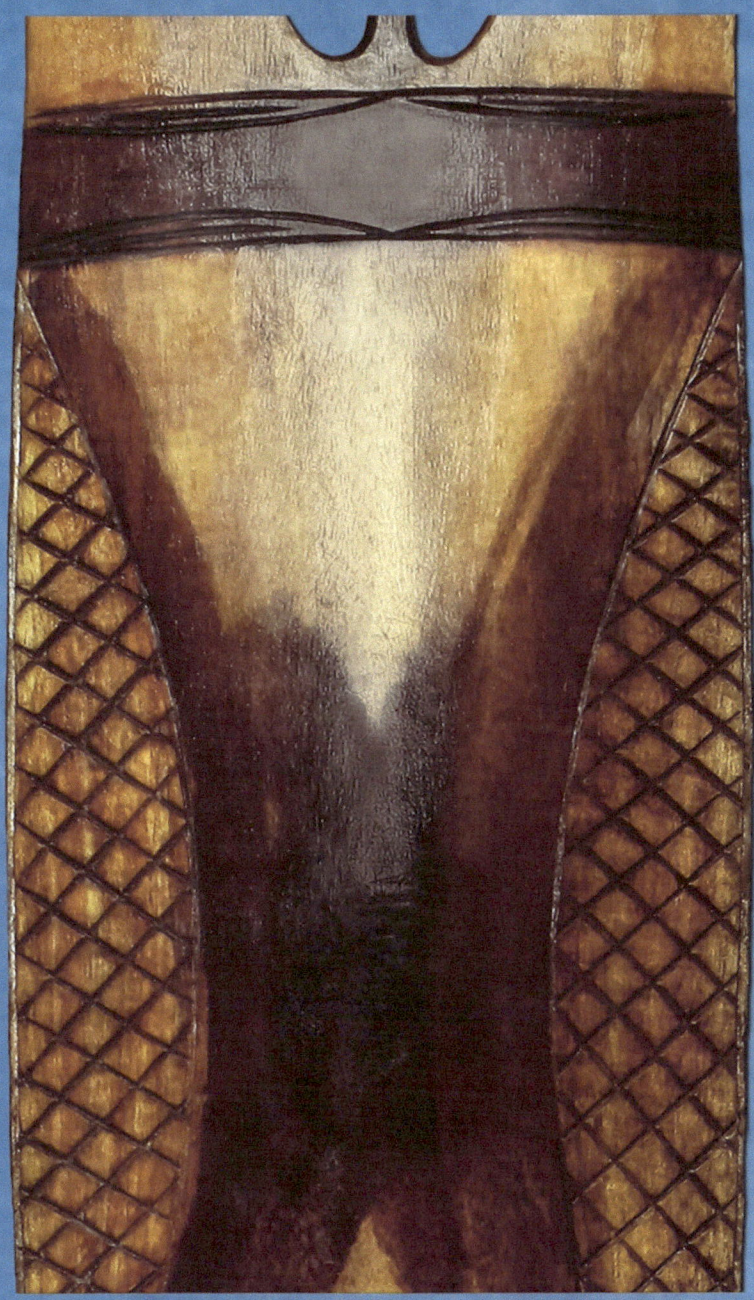

Igorot Shield: #25 Philippines Igorot Shields

Description:
 This is a vintage hand carved Philippines Ifugao, Igorot Bontoc Ceremonial Wooden Shield. This particular shield is referred to as a kalasag. It was created as a tourist piece for decoration or possibly used in a ceremony of some type.

Location Found:	Manila, Philippines	**Length:**	24 inches
Location Purchased:	EBay	**Width:**	7 inches
Approximate Age:	1970's	**Condition:**	Above Average

IGOROT SHIELDS of MOROLAND MUSEUM

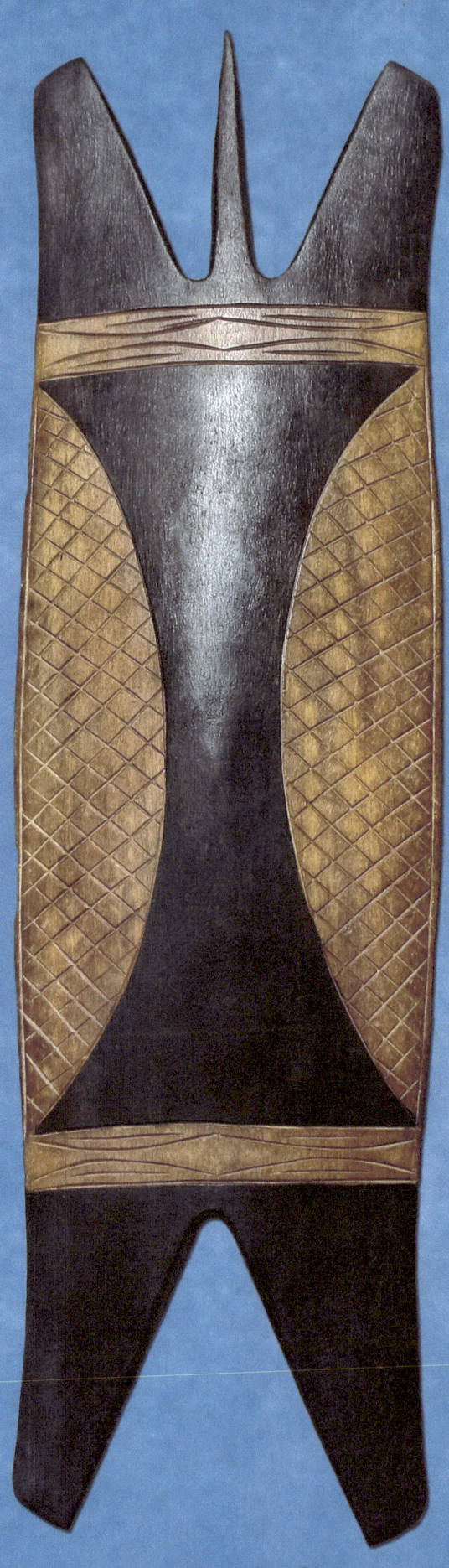

Igorot Shield: #26 Philippines Igorot Shields

IGOROT SHIELDS OF MOROLAND MUSEUM

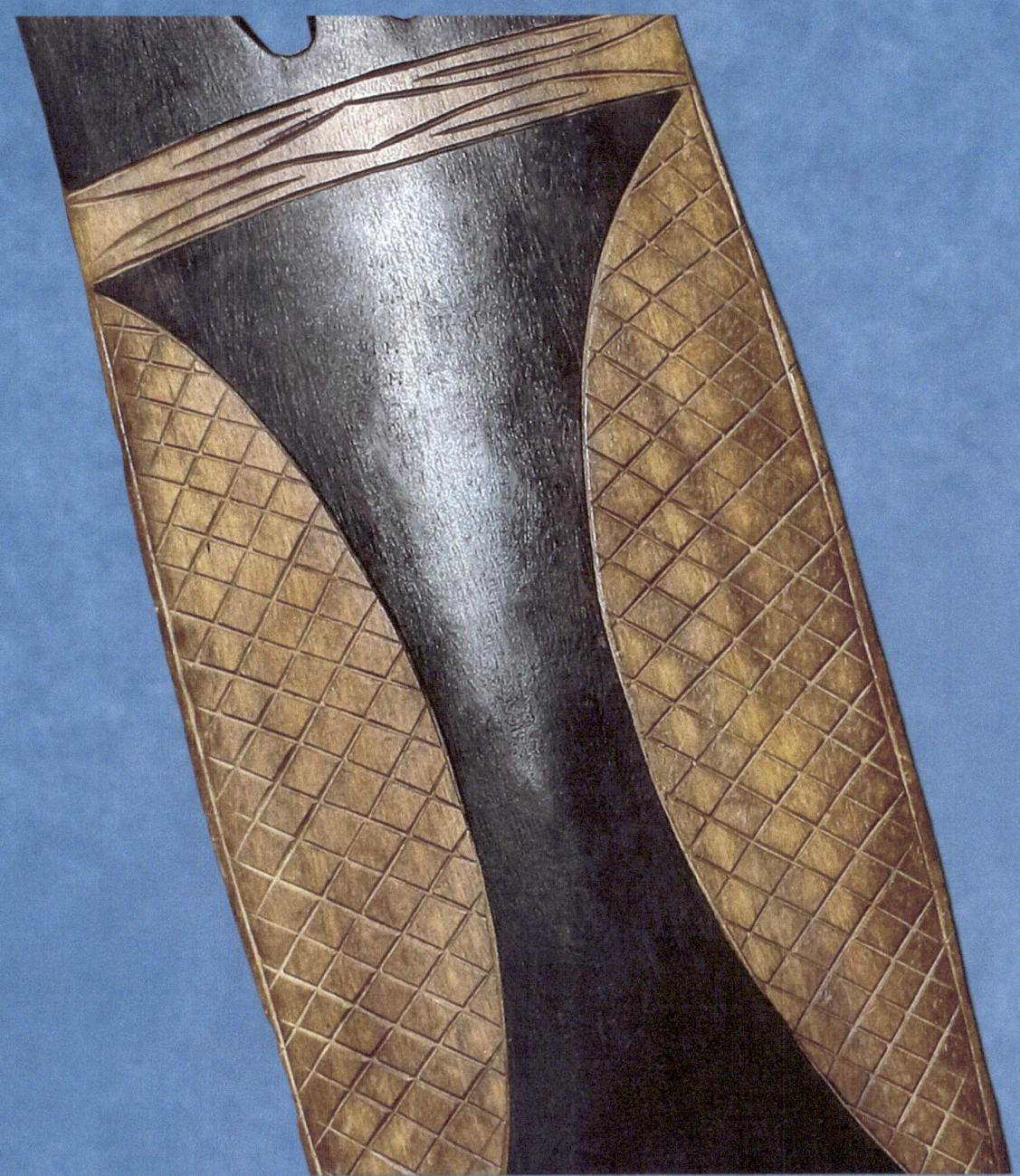

Igorot Shield: #26 Philippines Igorot Shields

Description:
 This is a vintage hand carved Philippines Ifugao, Igorot Bontoc Ceremonial Wooden Shield. This particular shield is referred to as a kalasag. It was created as a tourist piece for decoration or possibly used in a ceremony of some type.

Location Found:	Manila, Philippines	**Length:**	24 inches
Location Purchased:	EBay	**Width:**	7 inches
Approximate Age:	1970's	**Condition:**	Average

IGOROT SHIELDS OF MOROLAND MUSEUM

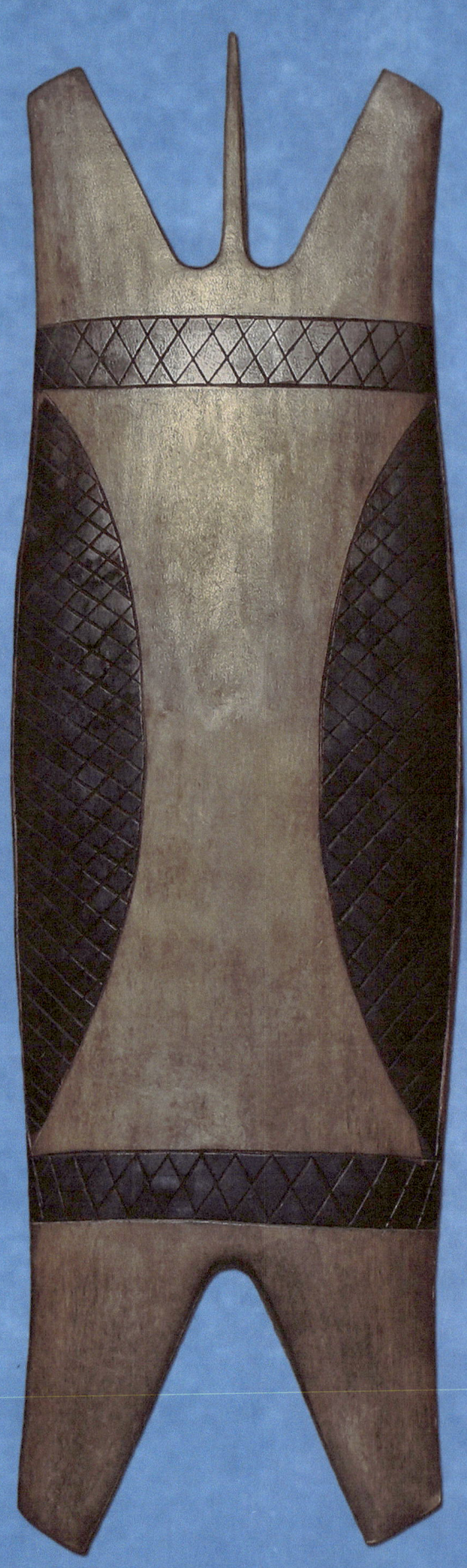

Igorot Shield: #27 Philippines Igorot Shields

IGOROT SHIELDS OF MOROLAND MUSEUM

Igorot Shield: #27 Philippines Igorot Shields

Description:
 This is a vintage hand carved Philippines Ifugao, Igorot Bontoc Ceremonial Wooden Shield. This particular shield is referred to as a kalasag. It was created as a tourist piece for decoration or possibly used in a ceremony of some type.

Location Found:	Manila, Philippines	**Length:**	24 inches
Location Purchased:	EBay	**Width:**	7 inches
Approximate Age:	1970's	**Condition:**	Above Average

LITTLE EXTRAS

of

MOROLAND

IGOROT SHIELDS of MOROLAND MUSEUM

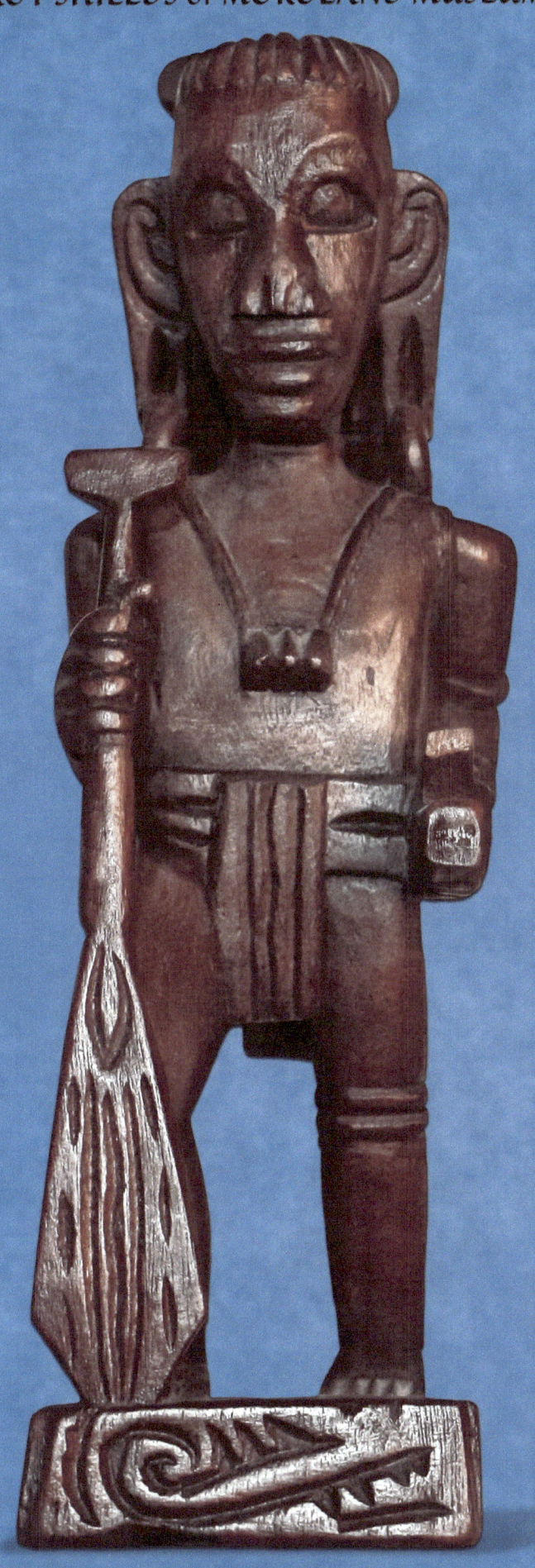

Extra: Wooden Male Villager

63

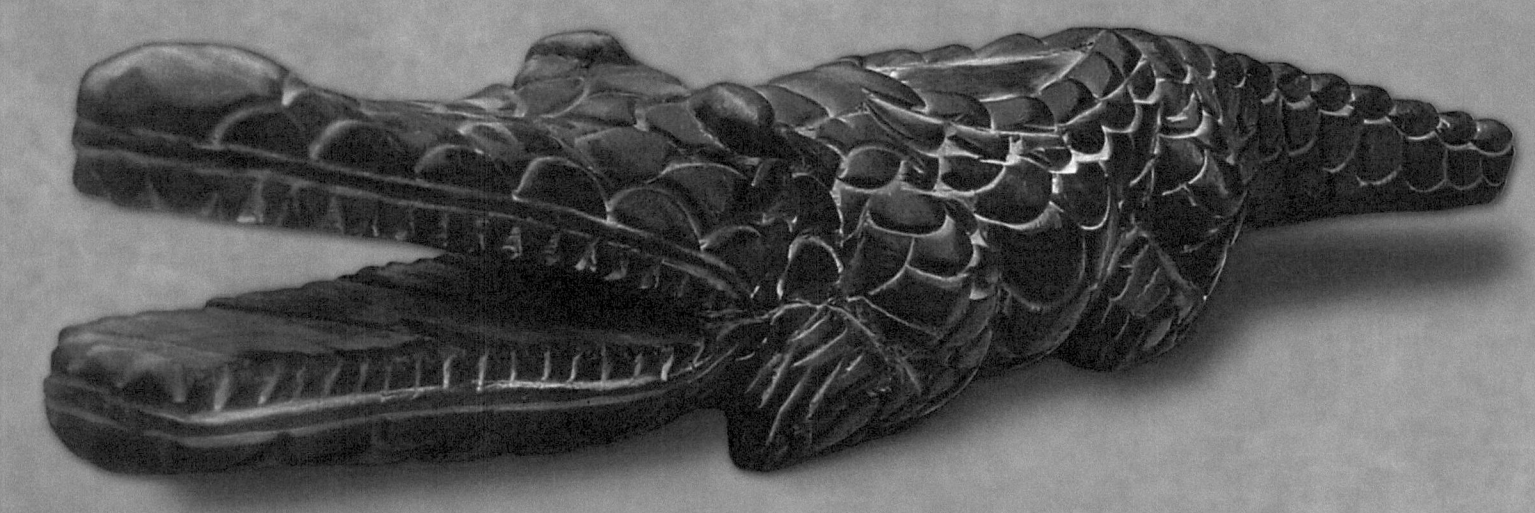

Extra: Wooden Alligator

IGOROT SHIELDS OF MOROLAND MUSEUM

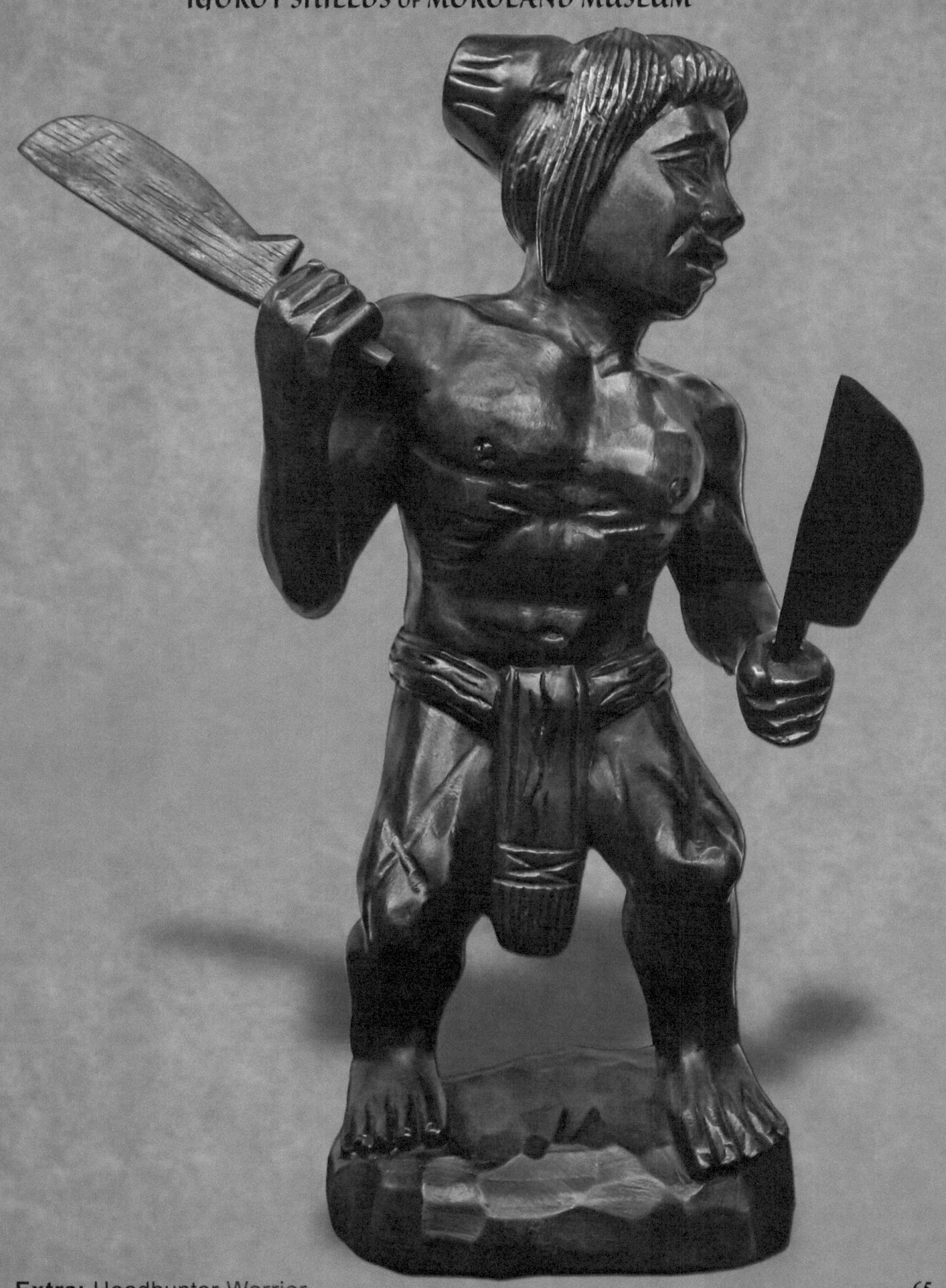

Extra: Headhunter Warrior

65

IGOROT SHIELDS of MOROLAND MUSEUM

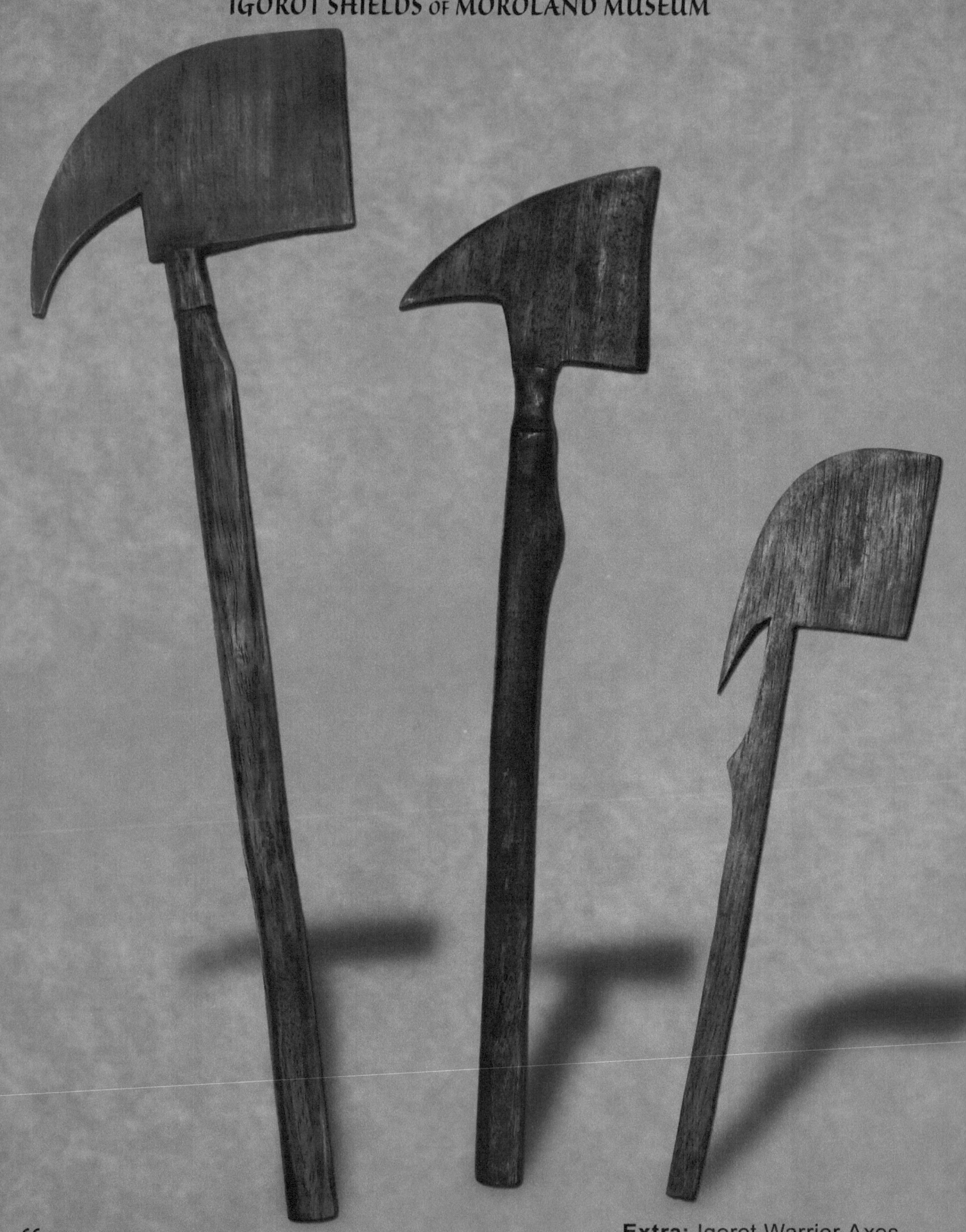

Extra: Igorot Warrior Axes

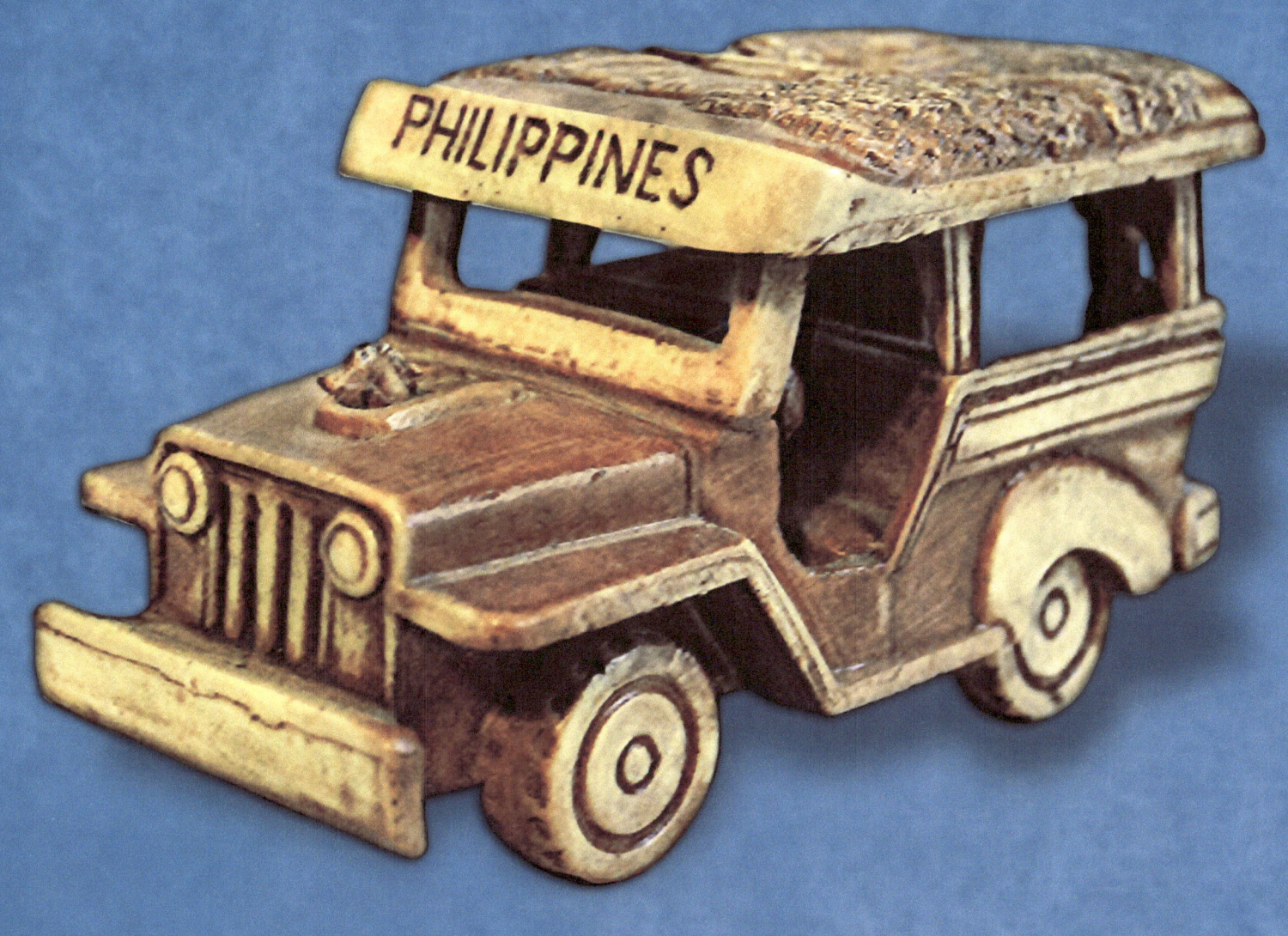

Carved wooden Jeepney from Makati City, Philippines, age = 1993, brought back by tourist.

Filipino (Tagalog) Language travel phrases for Jeepney or Bus:

Do you speak English?	Marunong ka ba ng ingles?
Do you understand?	Naiintindihan mo ba?
I don't speak Filipino.	Hindi ako marunong ng Pilipino.
I speak a little.	Kaunti lang.
Pardon?	Ano kamo?
Could you please speak more slowly?	Paki bagalan mo ang salita?

Conclusion

We hope this field guide of "Weapons of Moroland Igorot warrior shields volume #1" is as much a helpful tool for you to use when you are hunting for your next big find or as an asset to your collection for visual reference purposes.

This guide is the first volume in a set of volumes that Moroland Historical Publications will publish on the Moroland Museum's Igorot warrior shields collection. The next volume will display more unique Igorot warrior shields not shown in the previous volumes.

These Igorot warrior shields are a unique part of the Filipino craftsmanship and cultural history. The Moroland Historical Publications team is dedicated to preserving this history by publishing guides which document these artifacts for all to see and learn from. This is one of the largest collections of this type of Igorot warrior shields (that we know of) and is most likely the very first time they have ever been displayed in this format to the public.

We hope you have enjoyed viewing this guide as much as our team has enjoyed creating it.

IGOROT SHIELDS of MOROLAND MUSEUM

STATEMENTS

The writers of this book intentions were not to claim to be or imply in any way that they are experts or any kind of authority of Moroland history, art, language, or weapons, or of Philippine history, art, language, or weapons, or of any other countries history, art, language, or weapons. All of the weapons sizes and composition were an estimated guess at the time of printing.

All items are shown "as is". MOROLAND MUSEUM will not make any representation of warranty, expressed or implied, as to the marketability, fitness or condition of the items shown or described or as to the correctness of description, genuineness, attribution, size, provenance, location of origination, or period of the shown items.

The writers would like to say

THANK YOU

to those whose support and input made this book possible.

Our Spouses, Our Children, Our Friends
We would also like to thank those curious collectors who before us have preserved this part of our past and those whose skills, patience, and imagination made these items to begin with.

IGOROT SHIELDS OF MOROLAND MUSEUM
ABOUT NEXT EDITION

Dayak Shields of Moroland
field guide
sixth edition Vol #1

Dayak shields of Moroland Sixth edition volume #01 has a variety of Dayak shields to tempt your viewing pleasure.

This pictorial field guide will be a valuable asset to use when you hunt for an addition to your collection or if you are simply curious. It will have the same style of descriptions and lots of full color pages. It will also have those wonderful extras that you like so much. This edition will have a variety of Dayak shields that are from Malaysia and different regions within that country. The style of these shields vary from tribe to tribe and from the material they are made from. This book is a pictorial book as it contains multiple pictures of each shield and a brief description.

You will need to get the next issue to discover what other historical artifact delights await.

IGOROT SHIELDS OF MOROLAND MUSEUM

Additional Rare Books

Moroland Museum Historical Publications Book Series:

Kerises of Moroland Museum..........Book #1 on the unique Kerises (wavy blade swords) from the Moroland Museum Historical Archives, Volume #1.

Weapons of Moroland Museum.......Book #2 on the unique Weapons from the Moroland Museum Historical Archives, Volume #1.

Artifacts of Moroland Museum.........Book #3 on the unique Artifacts from the Moroland Museum Historical Archives, Volume #1.

Souvenir Weapons Plaque of Moroland Museum......Book #4 on the unique plaques from the Moroland Museum Historical Archives, Volume #1.

All Moroland Museum books are available for purchase on the Amazon website and can be purchased with discount when buying in bulk.

www.ingramcontent.com/pod-product-compliance
Lightning Source LLC
Chambersburg PA
CBHW050746180526
45159CB00003B/1362